The GROWN-UP'S GUIDE to PAINTING WITH KIDS

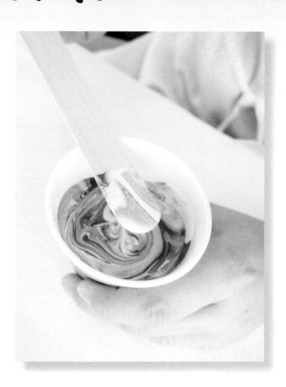

20+ FUN FLUID ART AND MESSY PAINT PROJECTS FOR ADULTS AND KIDS TO MAKE TOGETHER

Jennifer McCully

DEDICATION

For Phil, Rylee, Macie, Lily, and Curran—
You are my greatest adventure, my biggest support, my favorite place to be,
and all I'll ever need. My love for you extends past the moon and beyond the stars.
You are my forever and my always.
XOXO—Jennifer

A Special Thanks...
Curran, Macie, Grace, and Titus—
Without your help, patience, creativity, and ability to achieve,
the projects in this book would not have come to life.
I am forever grateful.

Inspiring | Educating | Creating | Entertaining

Brimming with creative inspiration, how-to projects, and useful information to enrich your everyday life, Quarto Knows is a favorite destination for those pursuing their interests and passions. Visit our site and dig deeper with our books into your area of interest: Quarto Creates, Quarto Cooks, Quarto Homes, Quarto Lives, Quarto Drives, Quarto Explores, Quarto Gifts, or Quarto Kids.

© 2020 Quarto Publishing Group USA Inc.

Artwork and text © 2020 Jennifer McCully, except photo on page 128 © Mya Blanton.

First published in 2020 by Walter Foster Publishing, an imprint of The Quarto Group. 26391 Crown Valley Parkway, Suite 220, Mission Viejo, CA 92691, USA.

T (949) 380-7510 F (949) 380-7575 www.QuartoKnows.com

Walter Foster Publishing titles are also available at discount for retail, wholesale, promotional, and bulk purchase. For details, contact the Special Sales Manager by email at specialsales@quarto.com or by mail at The Quarto Group, Attn: Special Sales Manager, 100 Cummings Center, Suite 265D, Beverly, MA 01915, USA.

ISBN: 978-1-63322-854-2

Digital edition published in 2020
eISBN: 978-1-63322-855-9

In-House Editor: Annika Geiger

Printed in China
10 9 8 7 6 5 4 3 2 1

TABLE OF CONTENTS

INTRODUCTION

Get ready to paint, pour, tip, tilt, and flow into a magical world of endless possibilities. Painting is one of the most colorful activities you can experience with a child. Both of your imaginations will run wild creating one-of-a-kind artwork. You can create side-by-side, each making your own separate masterpiece, or take turns pouring different colors onto a single surface. There is no right or wrong way to pour, which makes the projects in this book perfect for beginning painters and artists of all ages.

Paint pouring requires equal parts willingness to experiment, science, inspiration, and patience. The trick to creating paint-pouring masterpieces is knowing when to stop moving the paint around. As soon as you love what you see, STOP…and let it dry!

Creating fluid art can become quite addictive for you and the kids in your life! Playing around with endless color combinations, trying new pouring techniques, and adding glitter to your paintings will give anyone the creative giggles. Once you've set up your creative space, the joy of trying all the different techniques—and even making up a few of your own—makes paint pouring the perfect art activity for children of all ages.

The introductory sections in the book will help you and your children get your creative space set up before diving into the creative prompts, which will help you get your creative juices flowing. The creative prompts are not meant to be finished works of art; rather, they are designed to get you to loosen up and be fearless in your creative process. The step-by-step projects found throughout the book will not only teach you and your kids how to make incredibly colorful paintings together, but also how to use paint pouring as just one part of a finished art project, making that project extra special as you learn how to adapt it to different surfaces, color combinations, and more.

No experience is needed to get flowing. So, grab your supplies, set up your creative space, and let's start painting!

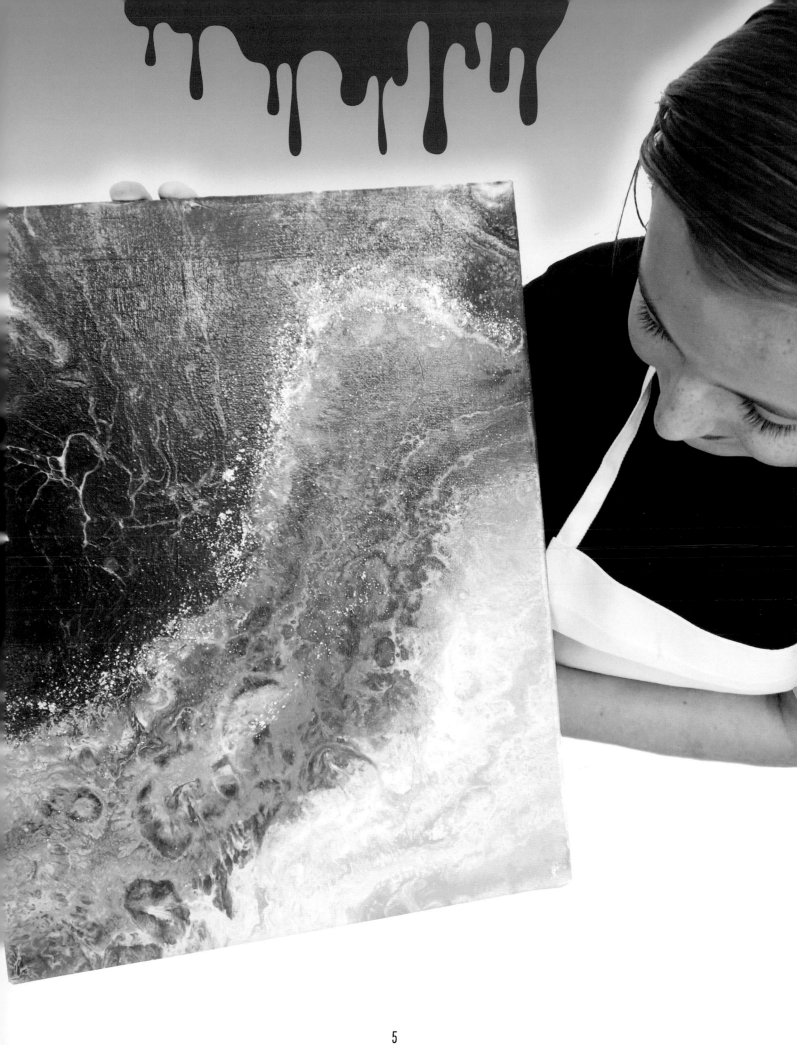

TOOLS & MATERIALS

You can use a wide variety of tools and materials for paint pouring. Most of the supplies are affordable and easy to find in craft stores, art-supply stores, home-improvement stores, and in grocery and dollar stores, as well as online.

POURING SURFACES

CANVAS is my favorite surface to pour on. Canvases are offered in a variety of shapes, sizes, and thicknesses. They are sold in craft stores, art-supply stores, and online—either individually or in multipacks—making canvas an economical surface for fluid art. Kids will love working on canvas, as the finished artwork is easy to display.

Larger canvases can sag in the middle from the weight of the paint and pouring medium, so keep a spray bottle of water on hand to spritz the back of the canvas. This will help tighten up the canvas. Before starting your piece, you can also prep a larger canvas by spraying the entire back with water. Be sure to spray all around the inside corners as well, and let the canvas dry completely before pouring paint on it.

WOOD also works well for paint pouring; however, make sure that the wood piece is not too thin. If the wood is too thin, your painting may warp from the moisture of the pouring medium. If your child prefers to pour on wood, make sure to lay the wood flat on a sheet of wax paper during the drying process to avoid further warping. You can find precut wood shapes, such as circles, ovals, and squares, where art supplies are sold, or cut your own wood pieces.

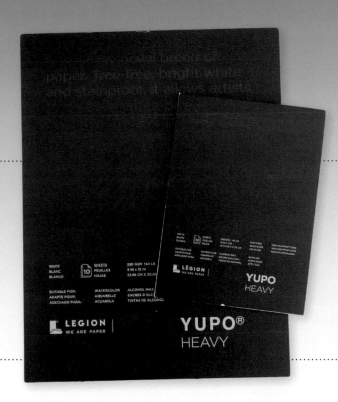

YUPO® HEAVY is super-smooth, waterproof, synthetic paper that's sold in a variety of sizes both online and in art stores. It's perfect for paint pouring because it will not buckle under the weight of the paint and lies flat, unlike other art papers. The projects in this book that require YUPO Heavy include bookmarks, postcards, and artwork on larger sheets that can be framed.

CERAMIC TILES are perfect for creating coasters and magnets. They can be found at home-improvement stores and in tile and floor retailers.

CRAFTWRAP™, or plaster cloth, is a gauzelike bandage material that's easy to use for various plaster projects and the "With All My Heart" project (page 50). It can be found online and in craft stores.

CARDBOARD can be cut up to make shapes for paint-pouring projects, so save those boxes from your online orders! Cardboard does warp when used in fluid-art projects; however, if your cardboard pieces are small enough, warping should not occur.

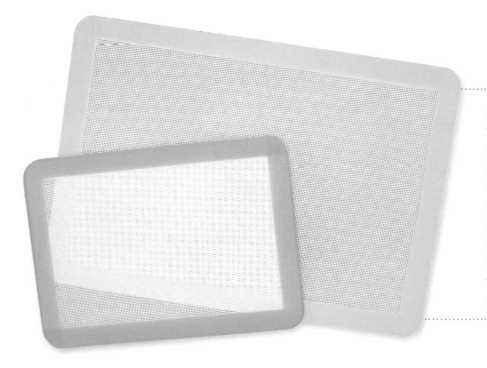

SILICONE BAKING MATS work well as surfaces for leftover paint. Once completely dry (after about 24 to 36 hours), the poured paint can be peeled off in a single piece, forming a sheet of acrylic paint or acrylic skin to be used in a variety of projects and crafts. Silicone baking mats can be found online, in grocery stores, and in home-goods stores.

Acrylic Paint

Fluid-art projects are usually made from acrylic paint. There are many brands to choose from; however, I recommend keeping it simple and using inexpensive acrylic paints offered in a wide variety of colors. When creating with kids, inexpensive acrylic paints, also known as craft paints, offer the perfect consistency for pouring—not too thin and not too thick. If you prefer to use more expensive, artist-grade paints, that's fine too.

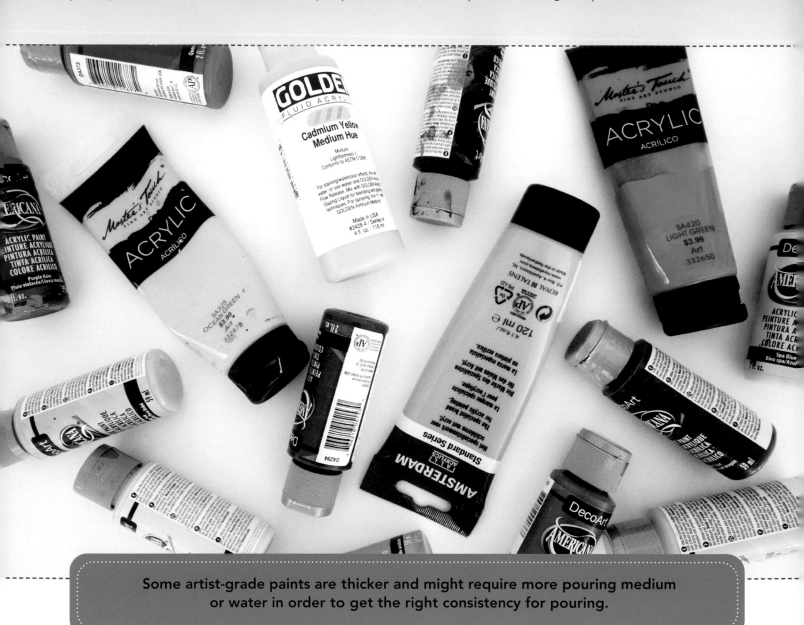

Some artist-grade paints are thicker and might require more pouring medium or water in order to get the right consistency for pouring.

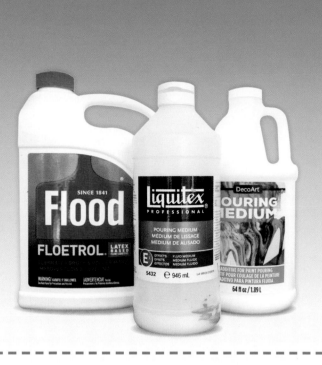

POURING MEDIUMS

Pouring mediums are added to acrylic paint to make the paint thinner and more fluid. Different brands are available and can be found at craft stores, art-supply stores, and online. The projects in this book use Floetrol®, a popular pouring medium that can be found in the paint section of home-improvement stores.

ENHANCING CELLS WITH ADDITIVES

Cells, the galaxy-like bubbles seen in fluid-art paintings, tend to form when there is a difference in density between paint colors. Cells can form just by using acrylic paint, pouring medium, and water; however, if you wish to enhance the look of your cells or create a painting featuring lots of cells, you will need to use additives.

There are two additives you can use to create cells in your fluid art: rubbing alcohol and products that include dimethicone. Some hair products contain dimethicone, making this additive easy to find even in grocery stores.

Don't hesitate to experiment with these two additives. Rubbing alcohol can replace the water in your paint mixture. Products using dimethicone can be added to your paint mixture, also as part of the pouring process; however, because products with dimethicone tend to be oil-like serums, you must still mix a splash of water into your paint mixture, along with a pump or two of dimethicone. Try pouring with each additive, as well as creating paint mixtures with both additives at the same time, and compare the results.

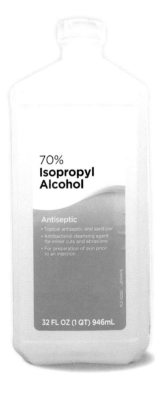

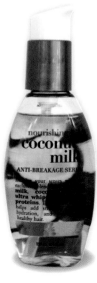

BASIC SUPPLIES FOR YOUR CREATIVE SPACE

It is important to properly set up your painting space. When your space is set up properly, you and your kids can create piece after piece without worrying about disrupting your creative energy if paint accidentally oozes off the edge of the canvas. Prepping your space with a clear drop cloth or an inexpensive vinyl tablecloth works best. Make sure the area is large enough for you and a child to work together with space to create more than one project at a time in case you end up with leftover paint that you want to use immediately.

Also, designate a place for your artwork to dry. Fluid art can take up to 48 hours to dry completely, depending on the size of the artwork and the thickness of the paint. Your artwork should lie completely flat and stay in one spot so that additional shifting or flowing does not occur during the drying process.

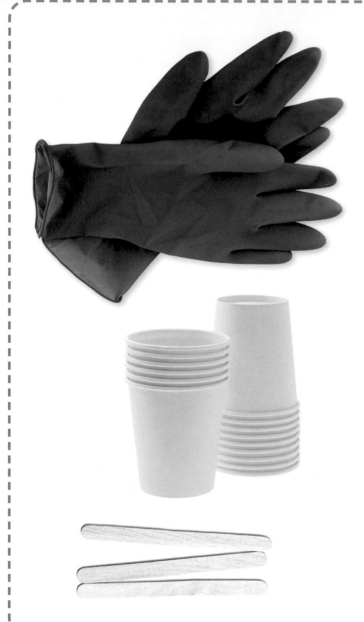

Here are some must-haves for your creative space:

- Drop cloth or inexpensive vinyl tablecloth

- Cups for pouring, propping, and drying (a variety of sizes)

- Wax paper

- Wooden stir sticks

- Baking sheets or foil or plastic trays for moving artwork around while it dries and to catch extra paint that flows off the edge of the artwork

- Disposable gloves (optional)

- A level to check your surface before pouring

- Masking tape for the back of the canvas

- Paper towels for cleaning up

- Small measuring cup for water

- Toothpicks to remove any unwanted clumps of paint before the artwork dries

- Palette or paper plate

Standard art supplies are also needed for some of the projects in this book. These include:

- Pencil, eraser, and pencil sharpener

- Scissors

- Paintbrushes (a variety of sizes)

- Mod Podge® glue

- Scrapbook paper

- Extra-fine glitter

- Scrap paper

- Gesso

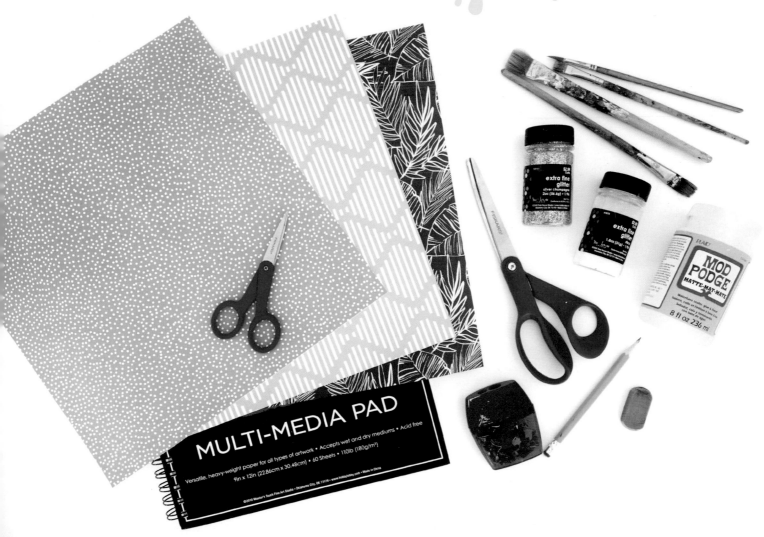

COLOR BASICS & INSPIRATION

When it comes to kids and paint, I find it easiest to keep things simple! Children don't overthink their color choices when creating; most are fearless and prefer to just dive in!

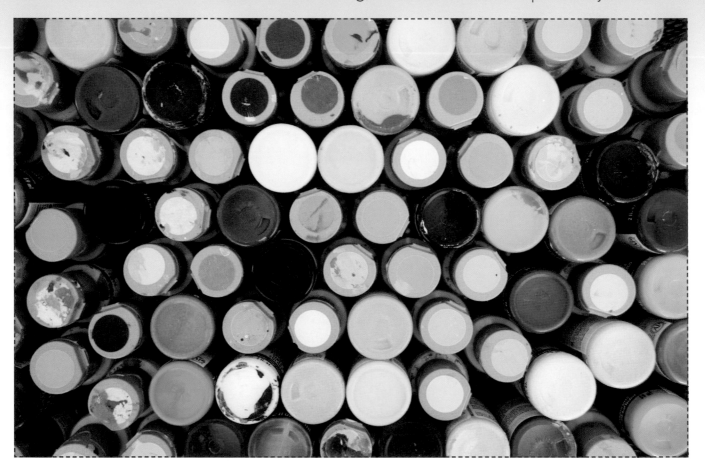

Understanding basic color theory can help keep your paint mixtures from turning muddy. Paint colors can mix in fluid art; however, it is mostly in the areas of a painting where one color overlaps another, so it is beneficial to explore different color combinations and see what colors work well together.

Looking for color inspiration and colors that go well together is easier than you think! Kids might love the colors in a favorite T-shirt, backpack, notebook, or cereal box. Adults might have a favorite sweater, album cover, or coffee mug that features the perfect set of colors to jump-start their artwork. Magazine ads, catalogs, and the paint section of home-improvement stores offer tons of color inspiration. Grab some masking tape and designate a small area in your home to tape up some of these items so that they are always visible for inspiration.

Keeping color inspiration near you takes the guess work out of figuring out what colors go well together.

The Color Wheel

Red

Purple

Orange

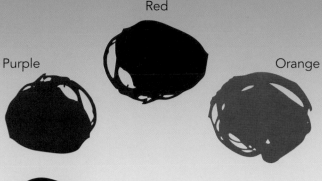

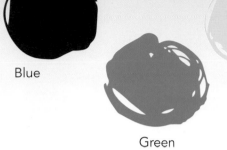

Blue

Yellow

Green

Secondary Color Chart

Primary Color + Primary Color = Secondary Color

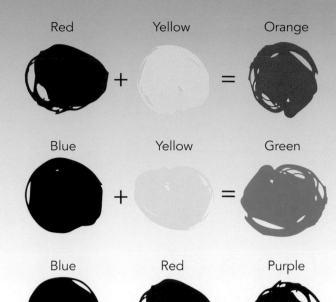

Red	+	Yellow	=	Orange
Blue	+	Yellow	=	Green
Blue	+	Red	=	Purple

Sample Color Palettes to Get You Started

Navy, Light Turquoise, Coral Pink, and Salmon Pink

White, Black, and Gold

Blue, Light Turquoise, Yellow, and White

Yellow, Light Turquoise, and Orange

Black, Light Pink, Gold, and White

Green, Aqua, and White

Blue, Light Turquoise, Yellow, Red-Orange, Pink, and White

Troubleshooting Tips & Tricks

MUDDY COLORS If your dirty pour painting (see page 16) comes out too muddy, too light, or too dark, immediately mix a small amount of two or three solid colors used in your dirty pour. Then pour each color separately onto your painting in the areas of the painting that you don't like and tip and tilt some more until you're happy with your painting. Your finished painting will have sections that resemble a dirty pour and sections that resemble a straight pour, giving your painting a whole new personality!

WHITE Don't forget to add some white to your color combinations! Because most people start with a white canvas, they often forget to add white to their color combinations when it comes to creating fluid art.

GLITTER If you like glitter, add it—whenever, however! Experiment with adding glitter to just one paint mixture before pouring, or sprinkle a bit of glitter in certain areas after your pouring is done. If you add glitter after your painting is done, do it while the paint is wet so that the glitter can dry into the paint.

TRICK OR A FIX? Not happy with a section of your newly poured painting? Try taking a small sheet of wax paper and gently swiping its edge over the area of the painting that you don't like. You can then tip and tilt the surface some more until the flow has shifted, or you can leave it as-is! You might like the way it looks after "swiping" it.

JUST NOT LOVIN' IT If you or your child just don't like the design of your poured painting once it is completely dry, don't waste the canvas or wood! Apply gesso over the entire surface, let it dry, and get pouring again! You will be amazed at how easy it is to rework a piece of art.

Mixing Paint

Paint, pouring medium, and water are the three ingredients needed to start mixing. Besides setting up your creative space and choosing paint colors, mixing paint is an important step in any paint-pouring project. You can't start pouring until you've mixed!

Using inexpensive acrylic paints makes mixing easier because the consistency of this type of paint is perfect for pouring! Your paint mixture should resemble warm honey or chocolate syrup. Typically, you will want to follow a ratio of 1 part acrylic paint to 2 or 2½ parts pouring medium. Then add just a splash of water and mix well. I keep a small measuring cup of water on-hand while pouring.

If you add too much water and the mixture becomes too thin, add more paint and/or pouring medium as needed. Your paint mixture should not be too thick to pour or lumpy. Your mixing ratio will not be perfect every time; however, the more you experiment, the easier mixing will become.

Right consistency

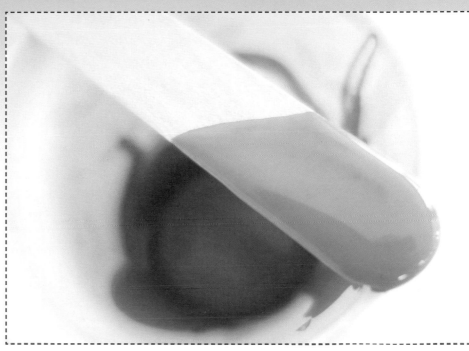

Wrong consistency

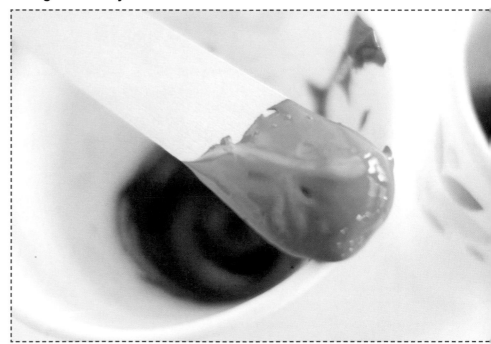

POURING TECHNIQUES

There are several techniques to experiment with when pouring paint. Each technique is unique, so try them all to discover your own favorites. Over the next few pages, I've featured basic examples of what some of the most popular pours look like, as well as a brief description of each. It is important to make sure that when working on a larger surface, you mix enough paint to cover the entire surface. If you go overboard and have more than enough paint mixed in the end, no worries—you can create a few acrylic paint skins to use in future projects. (See page 20 for more information on saving leftover paint.)

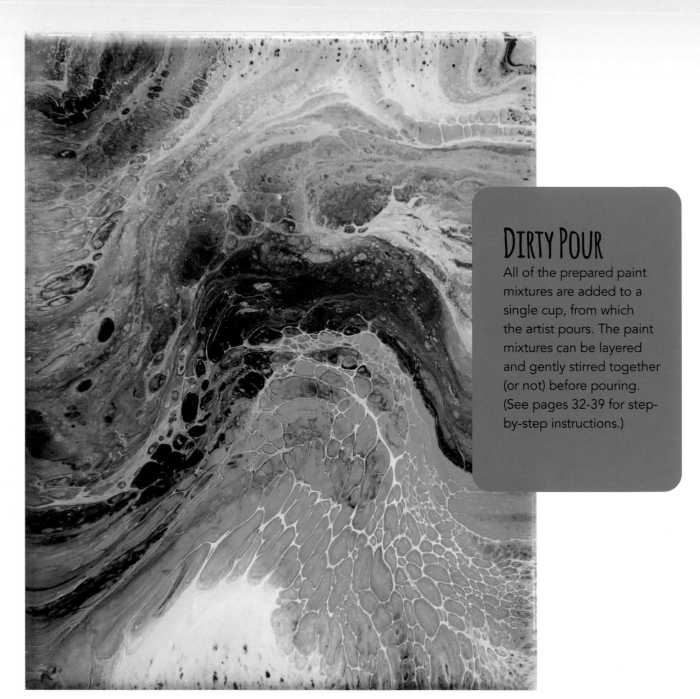

DIRTY POUR

All of the prepared paint mixtures are added to a single cup, from which the artist pours. The paint mixtures can be layered and gently stirred together (or not) before pouring. (See pages 32-39 for step-by-step instructions.)

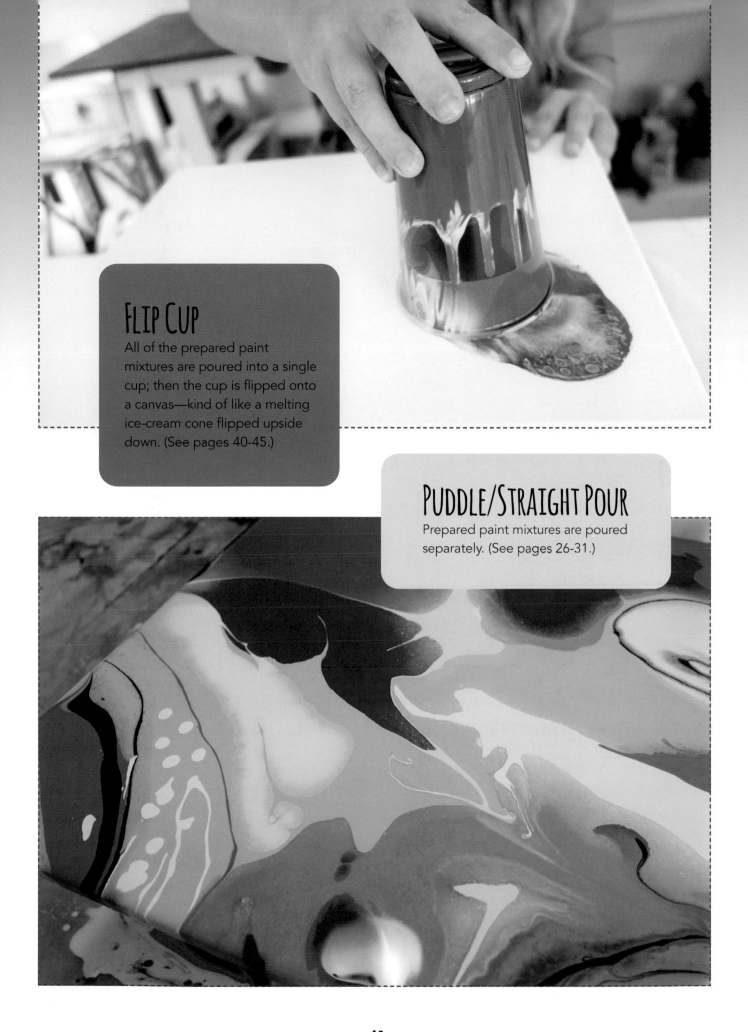

Flip Cup

All of the prepared paint mixtures are poured into a single cup; then the cup is flipped onto a canvas—kind of like a melting ice-cream cone flipped upside down. (See pages 40-45.)

Puddle/Straight Pour

Prepared paint mixtures are poured separately. (See pages 26-31.)

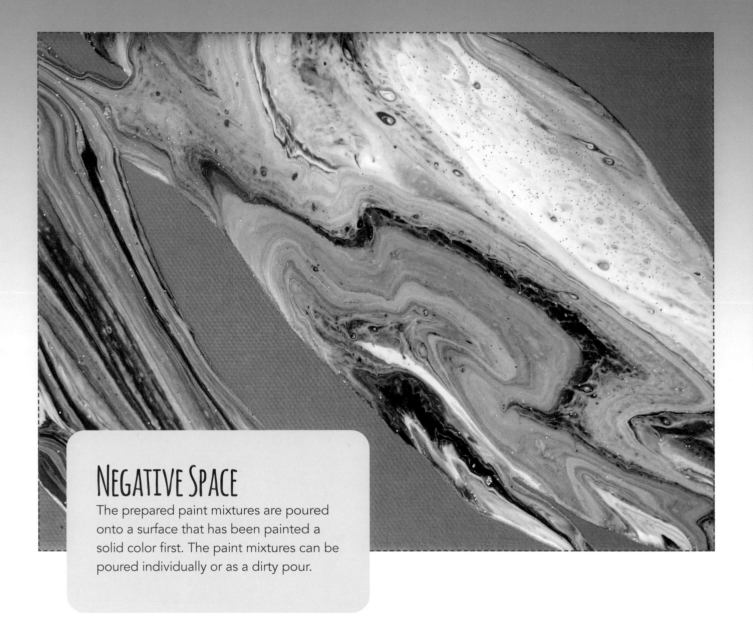

Negative Space

The prepared paint mixtures are poured onto a surface that has been painted a solid color first. The paint mixtures can be poured individually or as a dirty pour.

Try These Pouring Challenges!

1. Mix a dirty pour and a straight/puddle pour. After pouring all of the colors from a single dirty pour cup, fill in some areas of your painting with one or two of the solid colors used in your dirty pour.

2. Using a paint palette of six to eight colors, create three different dirty pour cups. With the flip cup technique, pour each dirty pour cup onto a different area of a single medium or large canvas. Let the cups sit upside down for a few minutes before releasing them. Once you pull the cups away from the paint, the real fun begins as you tilt and tip the canvas until it's completely covered with paint.

FINISHING ARTWORK

Once your artwork is complete, you can take a few steps to ensure that the paint doesn't run and your artwork is protected.

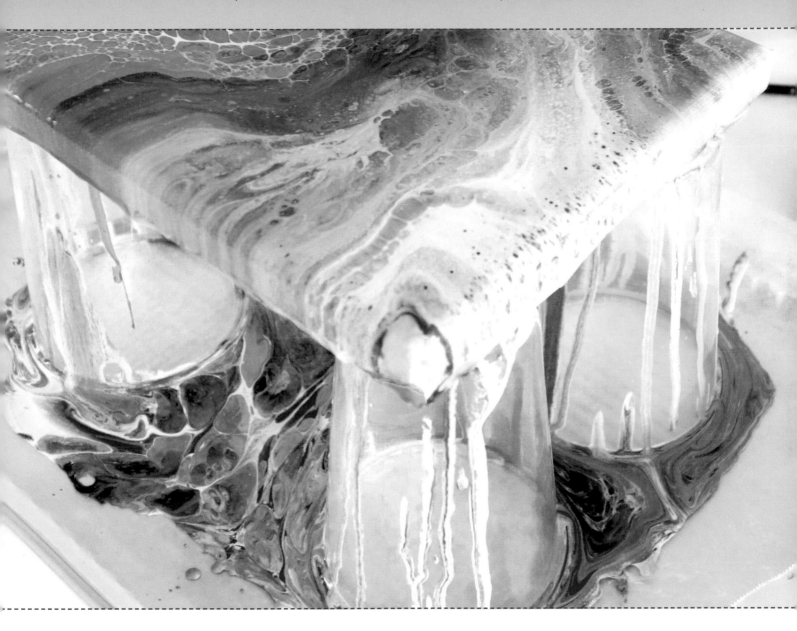

Lay your finished artwork on a flat surface to dry for 24 to 48 hours. If the surface isn't completely flat, the poured paint can and will shift and flow throughout the drying process, which will change the look of your painting. Check your surface with a level to ensure that it is flat.

While your artwork dries, you can leave it on the cups your canvas sat on as you poured, or you can lay the piece flat on a sheet of wax paper. If your painting needs leveling, use a small piece of folded paper, cardboard, or wadded-up foil underneath a corner or two as needed.

PROTECTING YOUR MASTERPIECE

Not all poured artwork needs to be protected or varnished. Projects done on Yupo Heavy paper can be left as-is, but I do recommend varnishing original paintings done on canvas, wood, coasters, and magnets. Varnishing your fluid artwork not only protects your artwork from yellowing but also adds a nice finished look to your piece. A gloss varnish will leave your paintings with a dreamy and vibrant look, whereas a matte finish will provide a duller look.

There are many different varnishes available, including spray varnishes, pour-on, and brush-on, and they can be purchased at craft, art-supply, and home-improvement stores, as well as online.

> Resin is a popular varnish for fluid art; however, when creating art with kids, you may want to avoid this potentially unsafe product.

BE SAFE!

Spray varnish is flammable and should be applied only by an adult working outside or in a well-ventilated area. Spray a thin layer of varnish on your artwork while it lays flat. Let the varnish dry completely; then you may apply another layer if you wish.

SAVING LEFTOVER PAINT

Below are a few suggestions for saving leftover paint. It's easy!

- Pour the paint onto a silicone baking mat and let it dry completely for 24 to 48 hours. Once dry, peel off the paint in one sheet and save the acrylic skin for a future project.

- If saving paint in the cups you poured from, cover them with plastic wrap and place a rubber band around the cups. You can save the paint for a week or two, if not longer.

- Pour the paint into any airtight container with a lid, such as a small plastic container or jar.

CREATIVE PROMPT

JUST ONE COLOR

The creative prompts in this book are designed to get the artistic energy flowing for you and the kids in your life. Don't worry about creating a complete work of art with these exercises; just go for it without worries or fear!

This creative prompt demonstrates how a single color can feature various shades or values. A color's value defines its lightness or darkness. Most color value charts start with the lightest value and work their way up to the darkest. Here, you will do the opposite: Start with one dark or bright color and use white to decrease the value of the color. Kids will learn the various shades they can create by adding more white paint to a color, making it lighter and lighter each time they make a mark on their paper.

Have kids set up their creative space by covering their work surface with a sheet of wax paper or a vinyl tablecloth and laying a piece of scrap paper nearby. Next, have them choose just one paint color. Squirt separate puddles of color and white paint on a paint palette or paper plate.

With a paintbrush in hand, have your child make the first mark on the paper with just the paint color, without adding any white. That mark will show the color's darkest or brightest value.

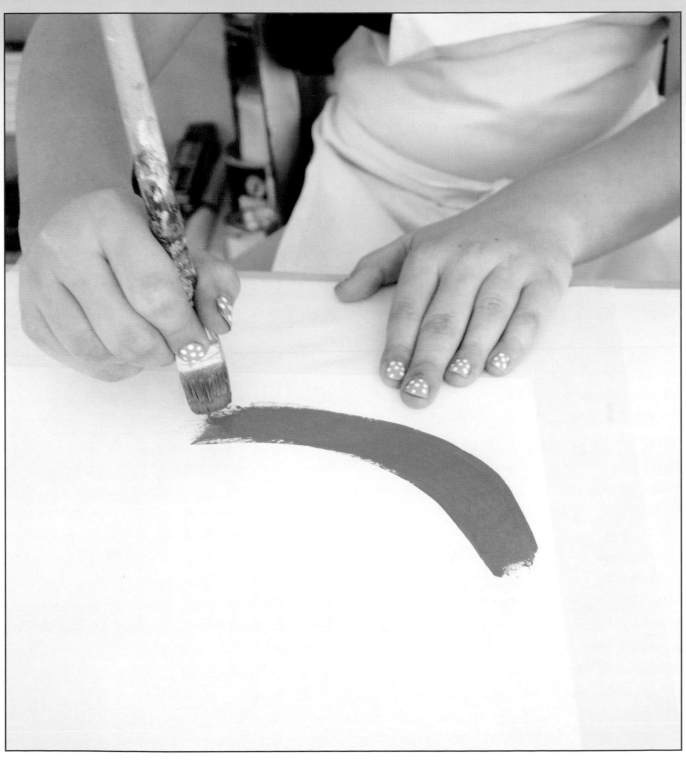

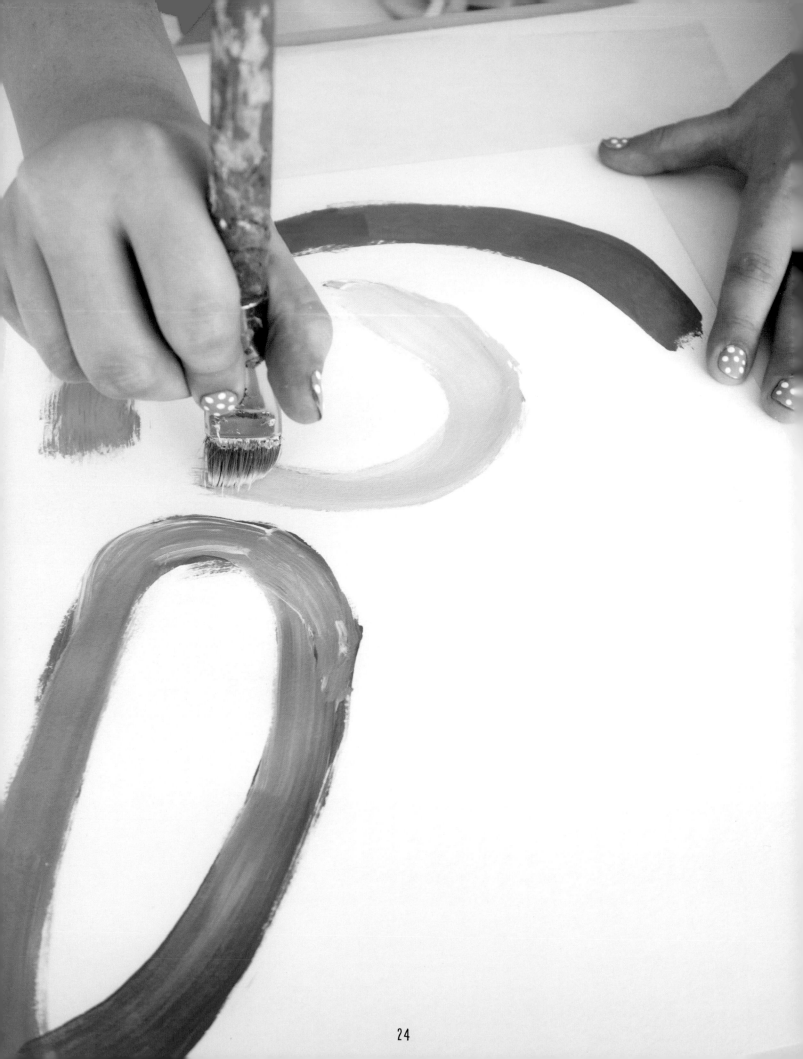

Next, have your child add a bit of white to the color, then progressively more, making a different mark on the paper each time white is added. The last mark added to the paper will be the lightest color or value.

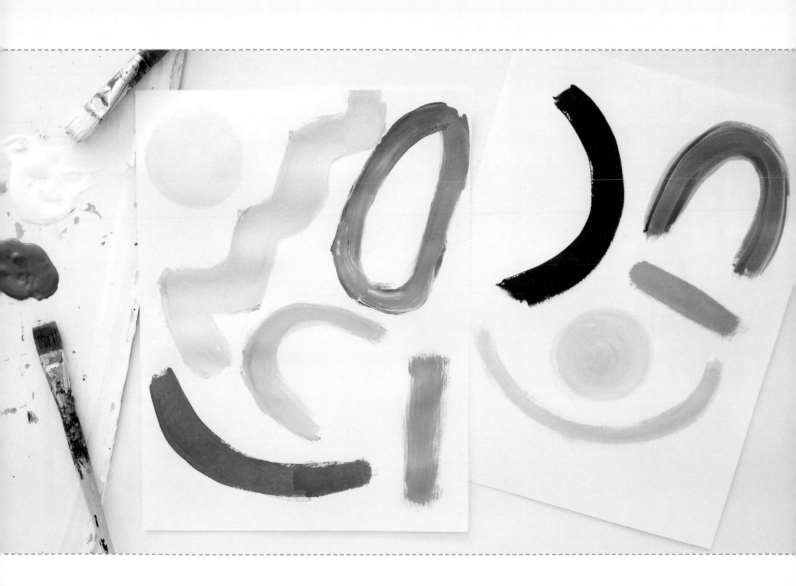

WILD & FREE: PUDDLE/STRAIGHT POUR

The puddle/straight pour is a unique pouring technique because it allows you to see the colors from your palette separately in the painting instead of all mixed together like in a dirty pour (pages 32-39). Your child will enjoy controlling how much or how little of each color to use!

TOOLS & MATERIALS

- Drop cloth or vinyl tablecloth
- Foil tray
- Wax paper
- Cups
- Canvas or wood surface
- Masking tape
- Acrylic paint
- Pouring medium
- Water
- Wooden stir sticks

STEP 1

Your child can set up the creative space, making sure to cover the working surface with a drop cloth or vinyl tablecloth. Line a foil tray with a sheet of wax paper. On top of the wax paper, place four cups upside down; then lay the canvas or wood surface on the cups. Tape the back of the canvas to protect it from paint and other materials.

STEP 2

Have your child pour the paint colors into individual cups.

STEP 3

Next, add pouring medium to the cups of paint. We used 2½ parts pouring medium to 1 part paint. Add a small splash of water and mix thoroughly, ensuring that there are no clumps in the paint.

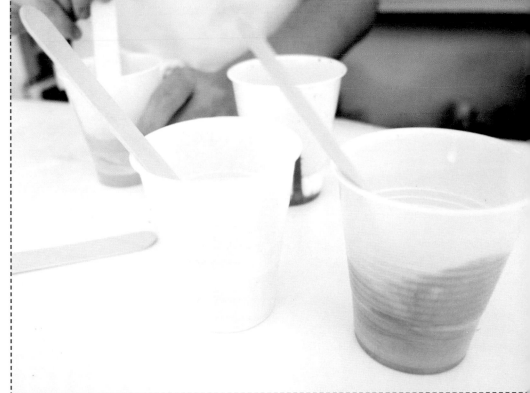

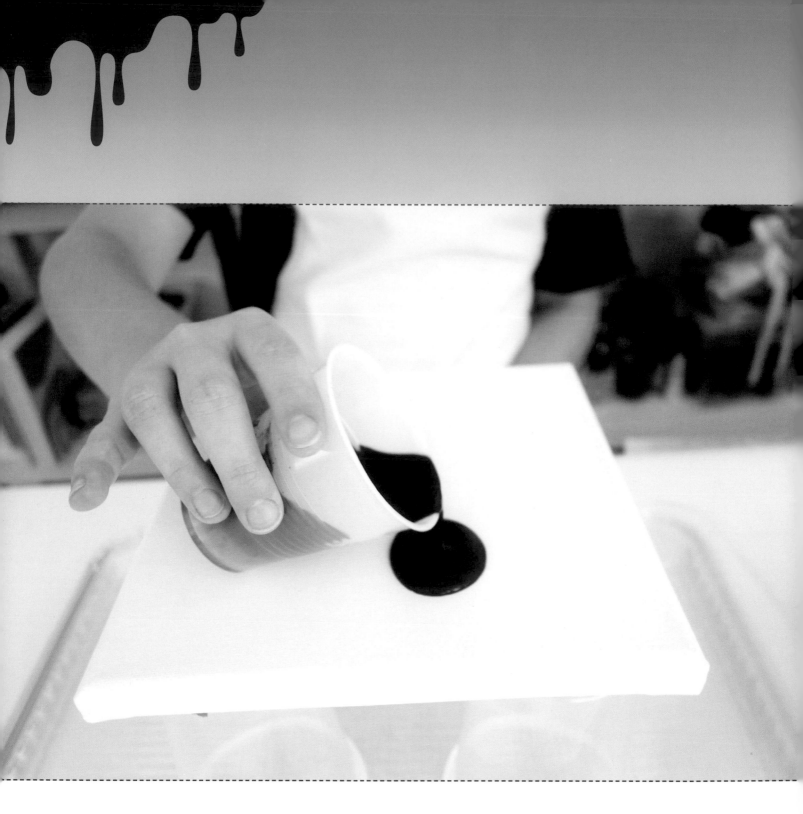

STEP 4

Because this technique does not require mixing all the pouring colors into one cup beforehand, your child can start pouring immediately, so just dive in! You can pour the paint colors in any order.

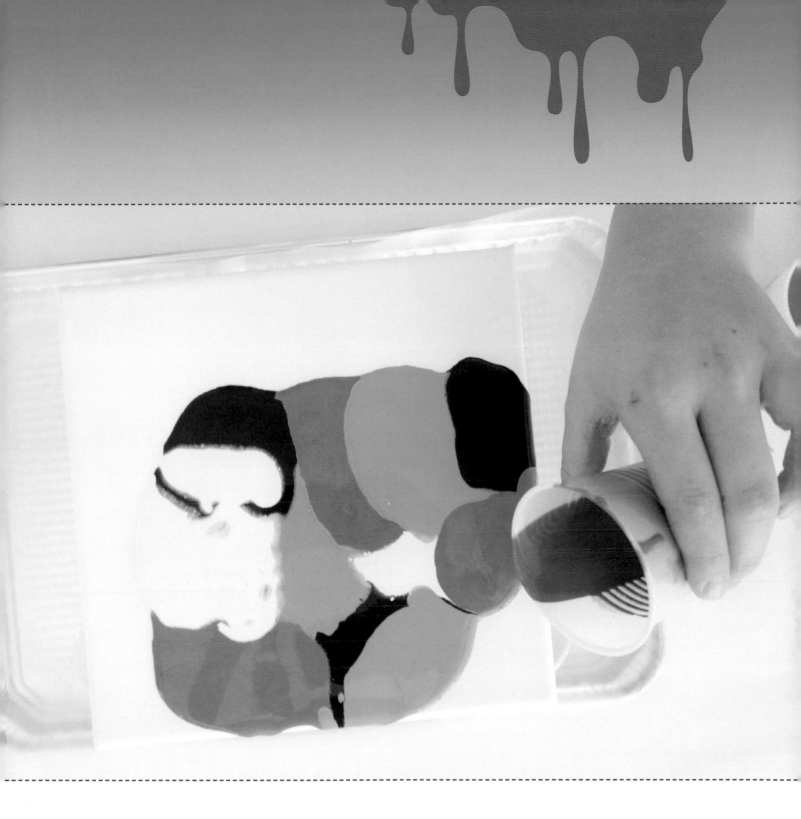

STEP 5

Choose another color and pour it on top of or next to your first paint color. We chose to pour the paint mixtures in different spots on the canvas first before puddling, or layering, them over each other.

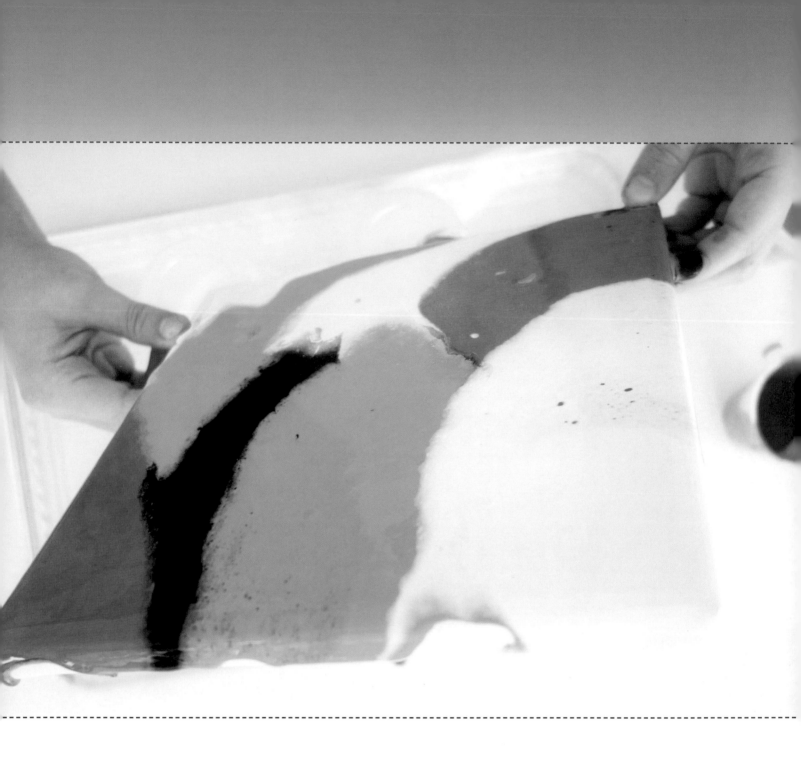

STEP 6

Once the canvas or wood piece is almost covered with paint, have your child gently pick it up and tilt the paint to cover the surface and its sides, causing new shapes to appear and the paint colors to flow together.

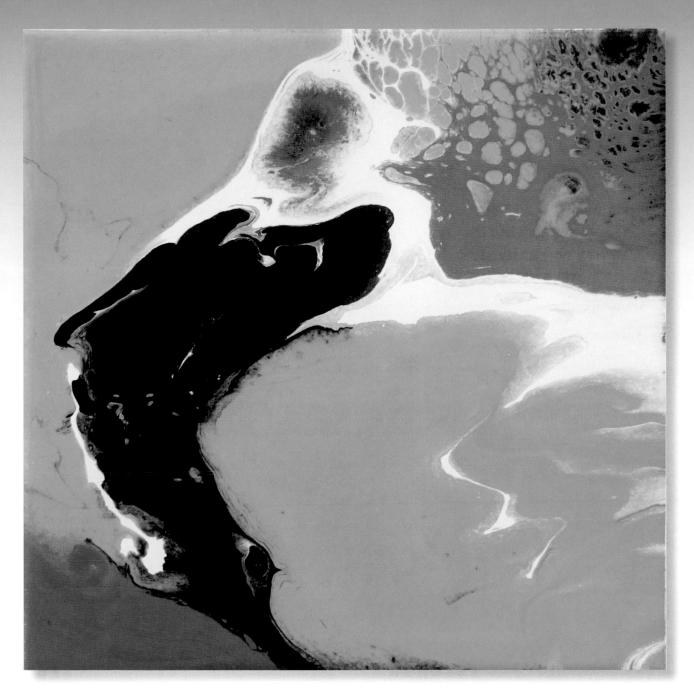

STEP 7

This last step can really change the look of a design. Pour any leftover paint on top of the design, focusing on the areas that you wish to make more defined and creating "puddles" or drops of paint to bring out your painting's true personality! Have your child tip and tilt the surface some more until you're both happy with the design. Then place the surface back on the cups to dry completely. If the surface is wood, lay it flat on a sheet of wax paper during the drying process to avoid warping.

STEP-BY-STEP PROJECT

DIRTY POUR

This project is all about experimenting! The more you experiment with colors, the more fearless you and your kids will become when it comes to creating fluid art.

It is important to remember not to mix too many dark colors into your pour or the design may turn out dark or muddy. When pouring paint, keep in mind that paint will dry darker. Try using white in your color palette the first couple of times you do a dirty pour to ensure that your design stays light and vibrant.

TOOLS & MATERIALS

- Canvas
- Masking tape
- Wax paper
- Foil tray
- Cups
- Acrylic paint
- Pouring medium
- Water
- Wooden stir sticks
- Optional: rubbing alcohol or dimethicone for creating cells

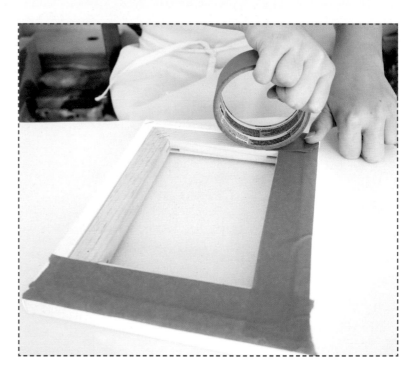

Creating the artwork on a tray allows you to easily move it to a place where it can dry. Just make sure the tray is level so that the design remains flat and doesn't shift during the drying process.

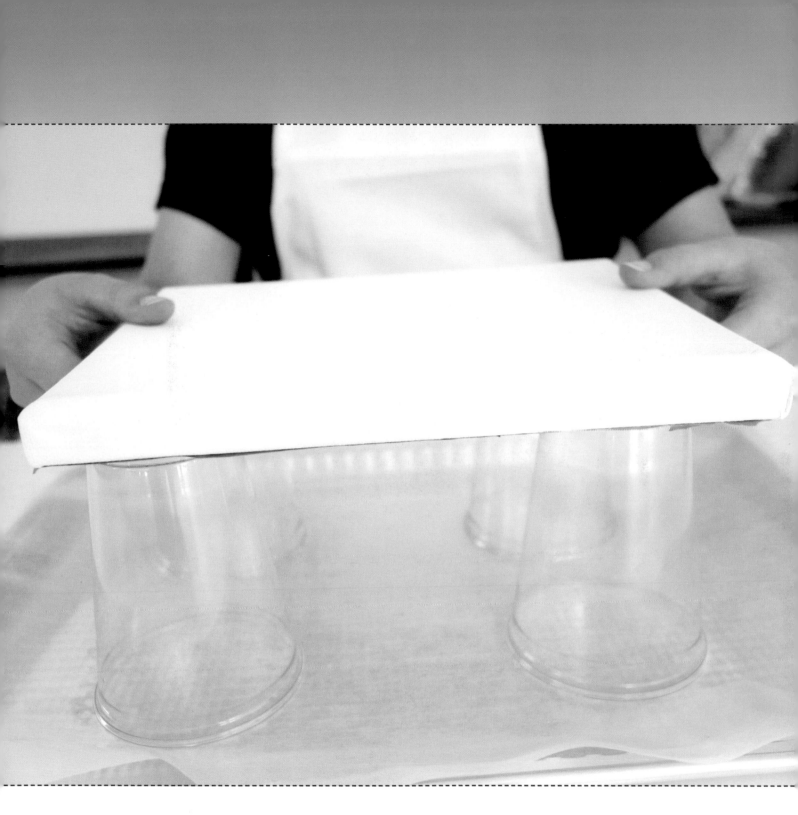

STEP 1

Have your child prep the back of a canvas with masking tape. Next, set up your creative space by placing a sheet of wax paper on a foil tray and laying your canvas on top of four cups.

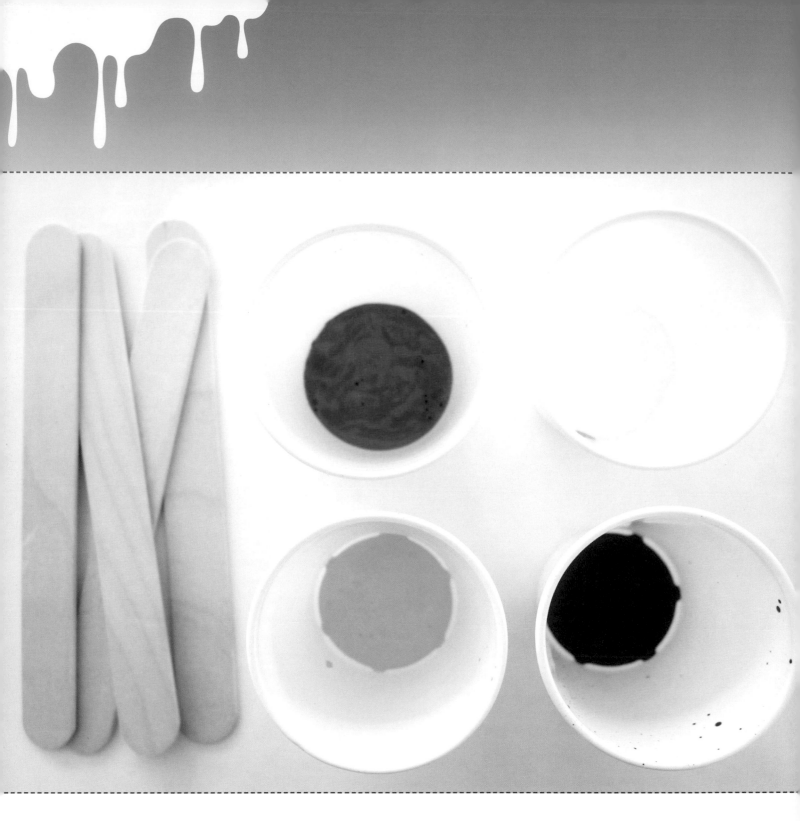

STEP 2

Add paint to separate cups.

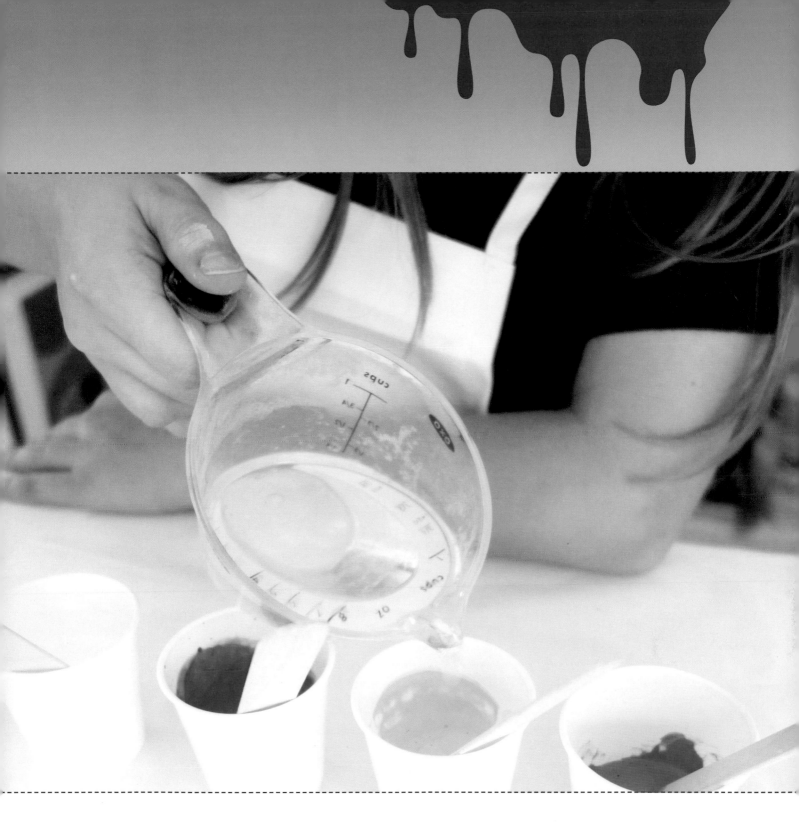

STEP 3

Have your child add pouring medium to each cup of paint. We used 2½ parts pouring medium to 1 part paint. Add a small splash of water and mix thoroughly, ensuring that there are no clumps in the paint.

If your child would like to create additional cells in the design, add a small amount of rubbing alcohol or 1 to 2 pumps of dimethicone to each color, instead of the water. Mix thoroughly until there are no clumps.

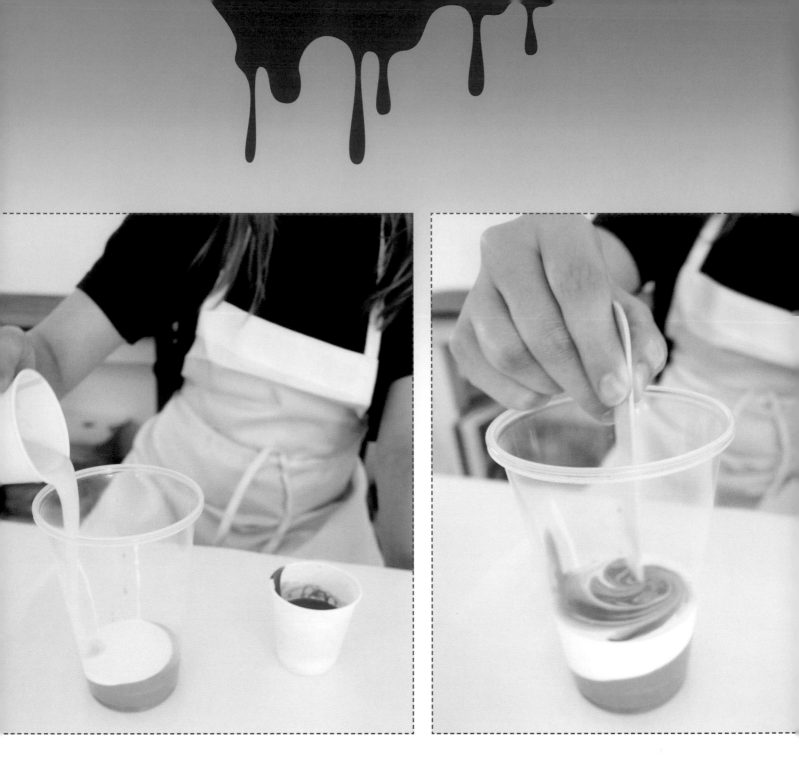

STEP 4

Pour the individually mixed paints into a single cup. You can pour each color, one right after the other, or you can slowly layer the colors.

Your child can gently stir the colors once they're in the cup, or pour the paint as-is. The choice is theirs! If your child chooses to stir the paint, one gentle swoop with a wooden stir stick is enough to avoid overmixing the colors.

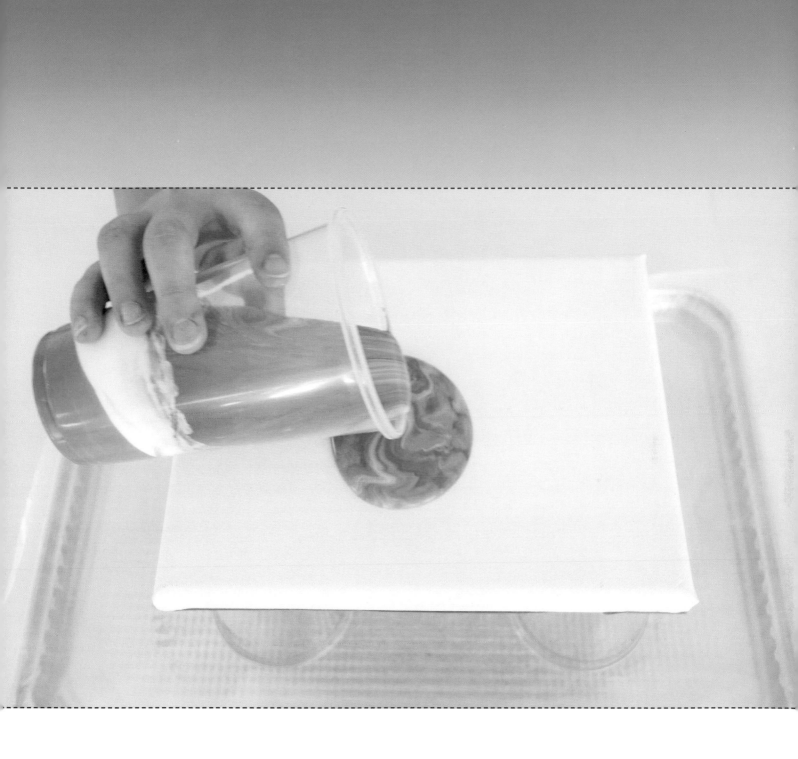

STEP 5

It's time to pour the paint onto the canvas! There is no right or wrong way to pour. You can start in the middle or on one side only, or pour in a circle or diagonally. Your child will enjoy the freedom to explore and be creative while pouring!

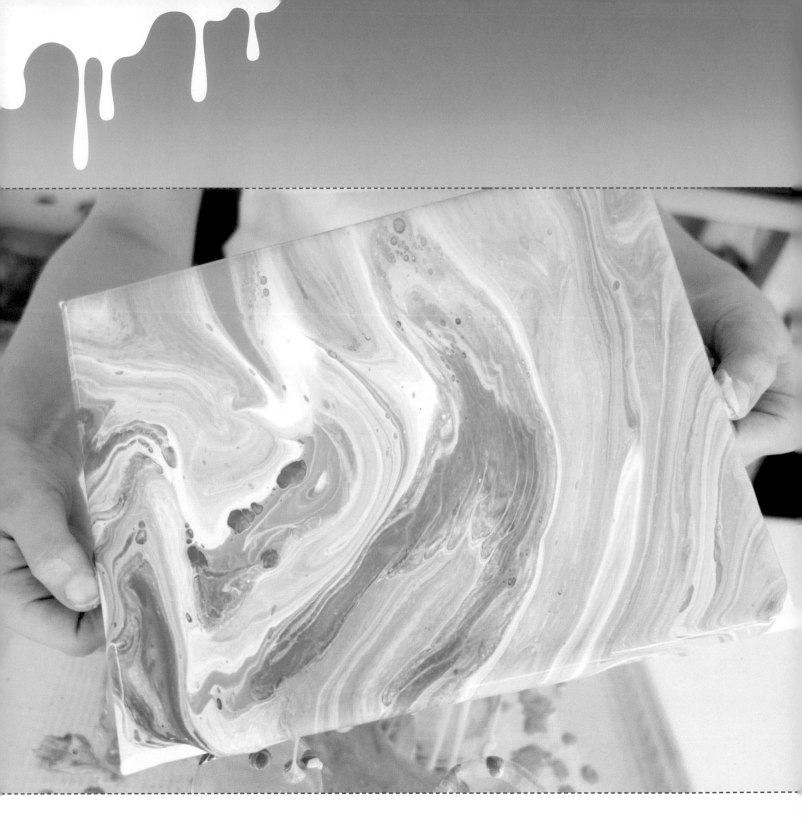

STEP 6

Have your child pick up the canvas and slowly start tilting and flowing the paint around until all of the canvas is covered, including the sides. If necessary, use your fingers to gently rub poured paint along the sides of the canvas to cover them. Keep the areas of the design you like, and tilt to change what you don't like. You can mix more paint if necessary.

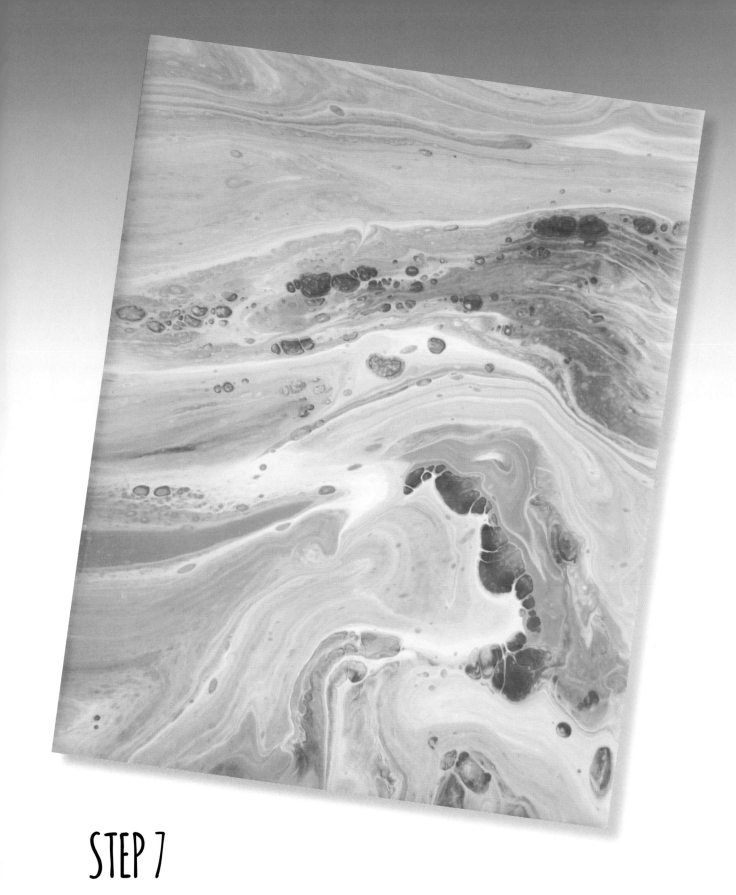

STEP 7

Remember: Fluid art truly is all about experimenting. You will know that your design is complete when you see it! And when you do, place the canvas back on the cups to dry completely. If you used a wood surface, lay it flat on a sheet of wax paper to avoid warping while drying.

JUST FLIP IT

This project will have you and your child "flipping out!" The flip cup technique is similar to a dirty pour: All of the paint mixtures are poured into a single cup. However, instead of pouring the single cup of paint onto the canvas, the cup is flipped upside down to let the colors ooze out like an upside-down ice-cream cone melting on concrete.

TOOLS & MATERIALS

- Wax paper
- Foil tray
- Cups
- Optional: masking tape
- Canvas
- Acrylic paint
- Pouring medium
- Water, rubbing alcohol, or dimethicone
- Wooden stir sticks

STEP 1

Have your child set up the creative space by placing a sheet of wax paper on a tray and laying the canvas on top of cups. Then pour the paint colors of your choice into individual cups.

STEP 2

Add pouring medium to each cup of paint following our usual ratio of 2½ parts pouring medium to 1 part paint. Add a small splash of water and mix thoroughly, ensuring that there are no clumps. If your child wants to add cells to the design, replace the water in each paint mixture with a splash of rubbing alcohol or 1 to 2 pumps of dimethicone. Mix thoroughly.

Now your child can pour the paint colors into a single cup, layering the colors on top of each other. Lightly stir the colors once, or leave them as-is. Do not overmix!

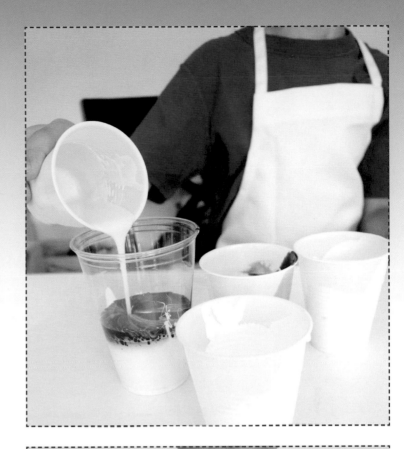

STEP 3

Let the magic begin! Help your child hold the canvas upside down over the cup with one hand holding the canvas and the other holding the cup.

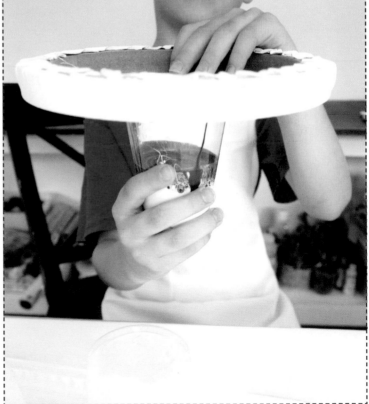

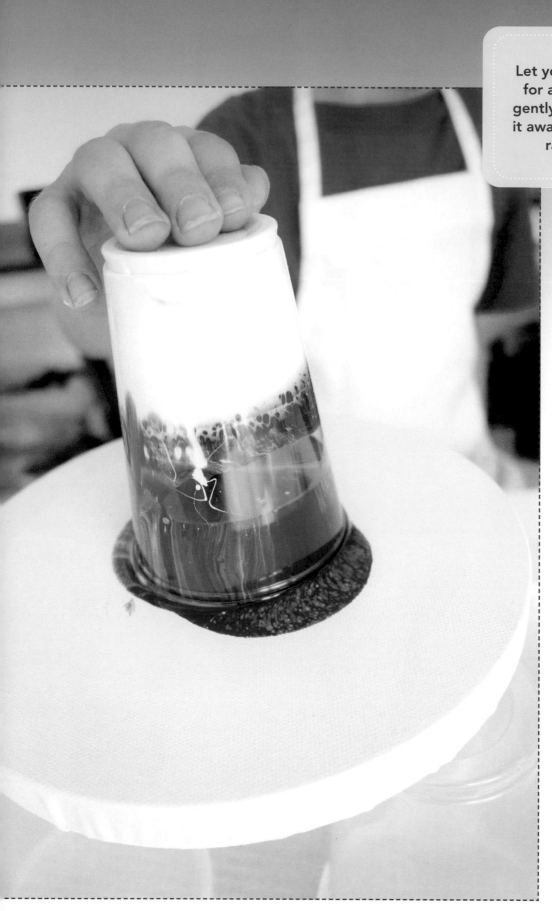

Let your cup sit upside down for a minute or two before gently releasing it and pulling it away from the paint puddle rather than lifting it.

STEP 4

Your child might need your help with this step as well. When your child is ready, the cup and canvas can be flipped over, leaving the cup to rest on top of the canvas. The cup can sit there for a minute or two—or not! You and your child will love watching the paint colors ooze out of the cup!

STEP 5

Have your child gently pull the cup away from the canvas, revealing total awesomeness! Ta-da!

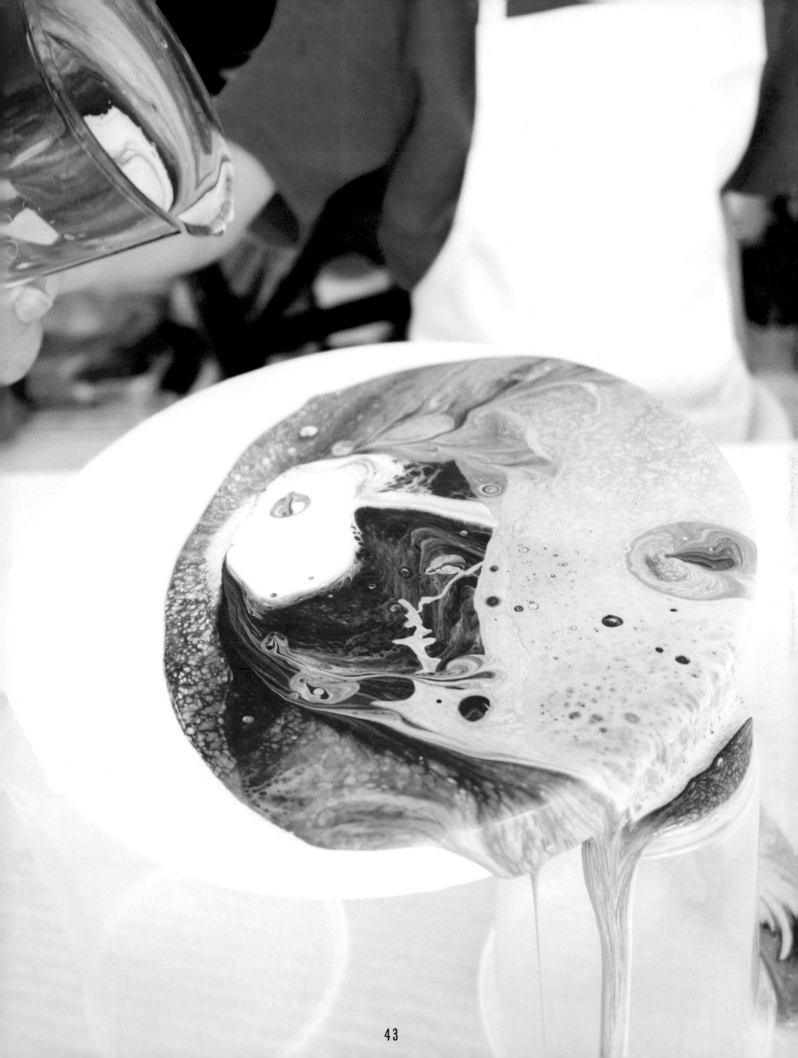

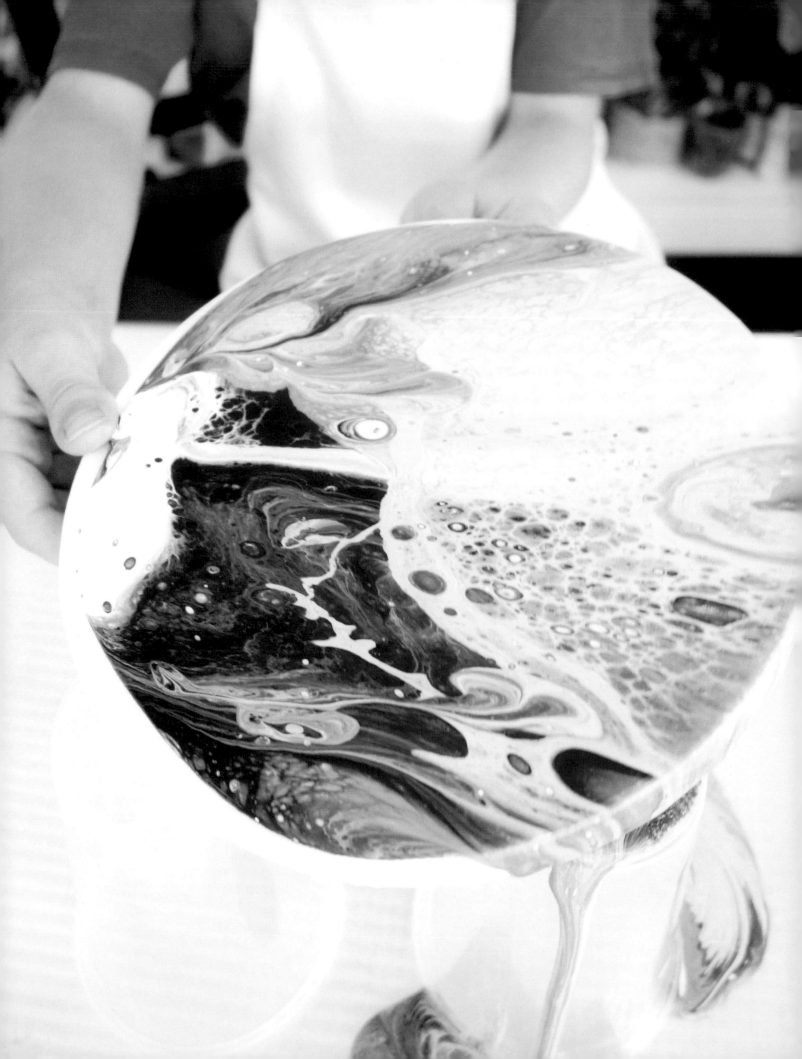

STEP 6

Your child can now pick up the canvas and slowly tilt it to let the paint flow over the entire surface of the canvas, as well as on the sides. Once your child is happy with the design, place the canvas back on the cups to dry completely.

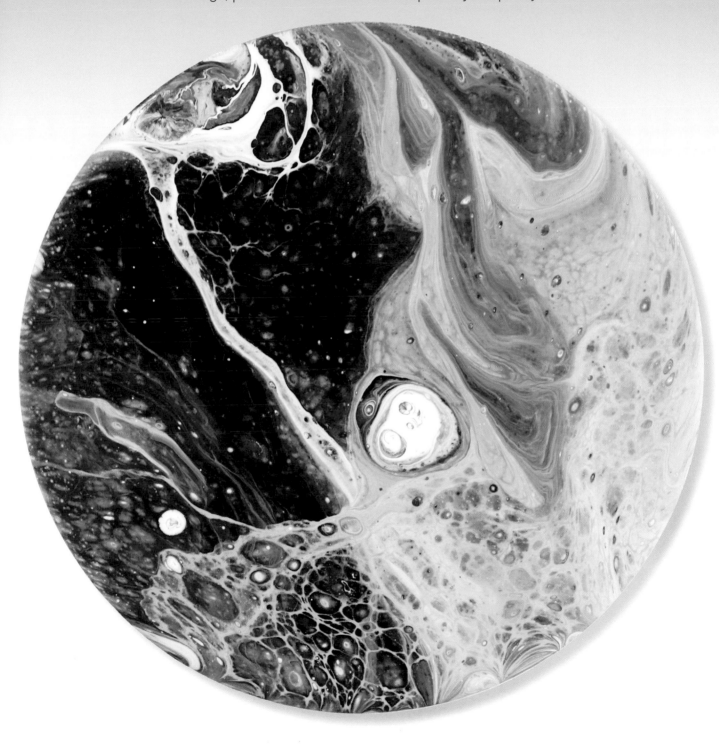

CREATIVE PROMPT

CLOSE YOUR EYES

This creative prompt will help you and your kids let go of artistic expectations and allow your minds to guide you as you create unexpected shapes, squiggles, and lines. You can use any colors you like here, and if your child prefers to use just one color, that's fine too! You just need a small amount of paint, pouring medium, and water.
Let go and go with the flow!

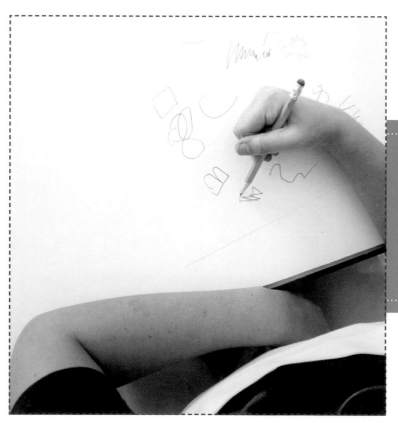

Have your child grab a piece of scrap paper and a pencil. Blindfold your child or simply have them close their eyes; then let the marks begin! Encourage your child to make random marks on the paper, without worrying about what they look like. This exercise is intended to help relax the mind.

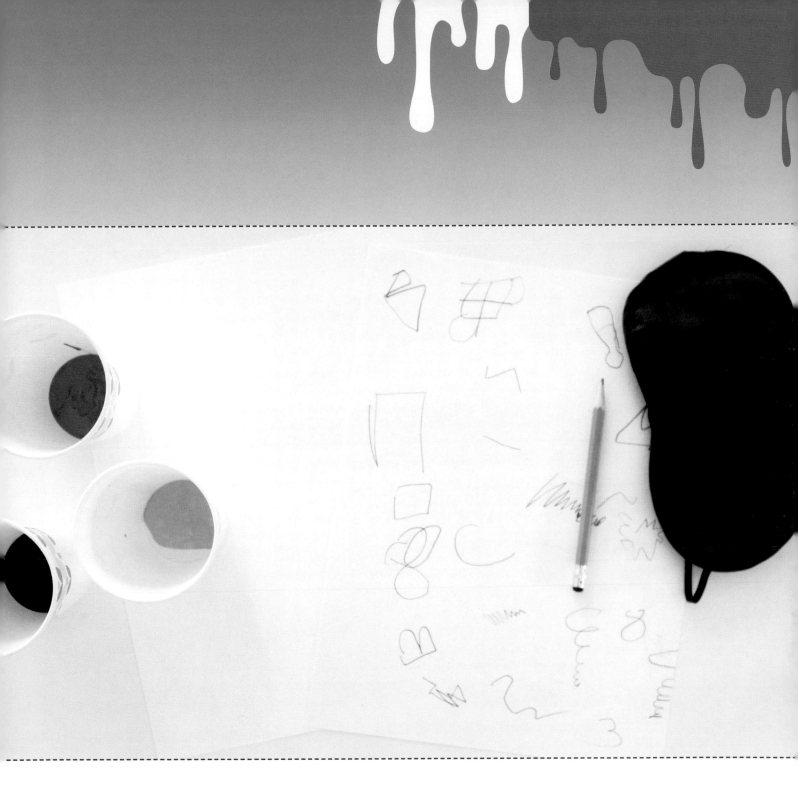

Once the paper is full of marks, have your child re-create the marks, lines, and scribbles by pouring paint onto a sheet of Yupo Heavy Paper, making the same shapes.

Before pouring the shapes, lay down a sheet of wax paper; then prepare the paint mixture. Use acrylic paint, pouring medium, and water to create a warm honeylike consistency for the paint mixture.

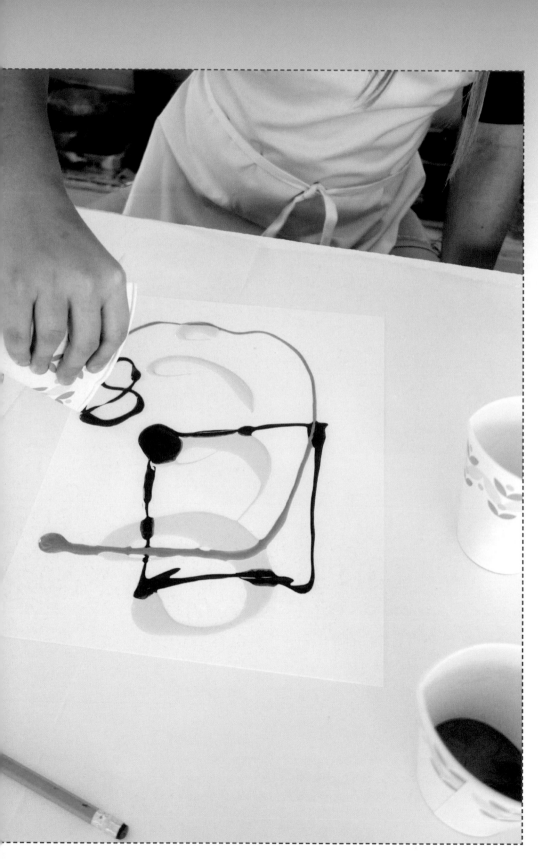

Now your child can re-create the pencil marks with paint! For this exercise, think big! The painted marks don't have to be done in the same size as the pencil lines; it may be easier for your child to create bigger scribbles, lines, and marks with the paint and watch how the flow of the paint changes the shapes of the marks. Try squeezing the cup rim together to create a finer, narrower pour. Once your child is done, set the paper aside to dry completely for 24 to 36 hours.

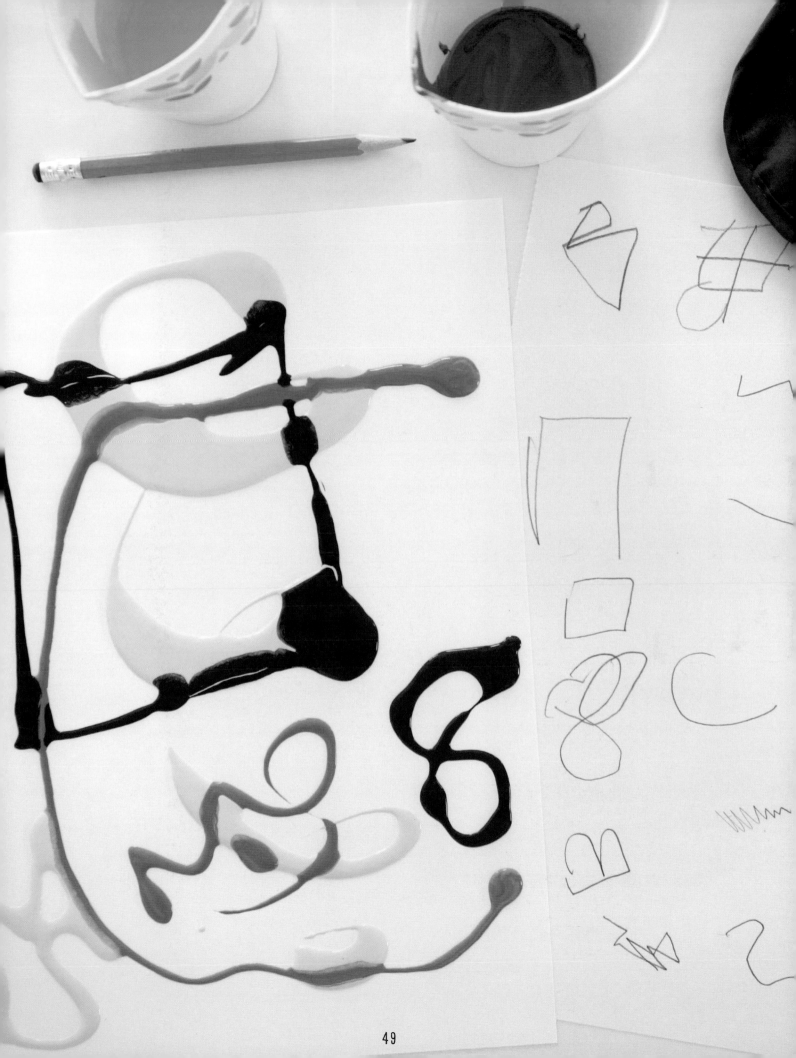

STEP-BY-STEP PROJECT

WITH ALL MY HEART

A heart symbolizes love, but also unity, friendship, kindness, thankfulness, and gratitude. When creating this project, have your child think about someone or something special. Projects made with love are always the most thoughtful, and this one-of-a-kind heart will be cherished for years to come.

Please note that extra drying time will be needed to complete this project, as the CraftWrap must be completely dry for you to pour paint on the heart.

TOOLS & MATERIALS

- Vinyl tablecloth
- Wax paper
- Pencil and eraser
- Sturdy cardboard
- Scissors or utility knife
- Aluminum foil
- Duct tape
- CraftWrap
- Cup of water
- Foil tray
- Cups
- Acrylic paint
- Pouring medium
- Water, rubbing alcohol, or dimethicone
- Wooden stir sticks
- Optional: extra-fine glitter
- Optional: sawtooth hanger

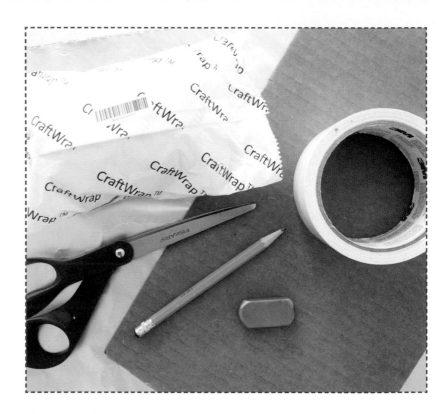

STEP 1

Gather the supplies and have your child set up the creative space by laying down a vinyl tablecloth and a few sheets of wax paper.

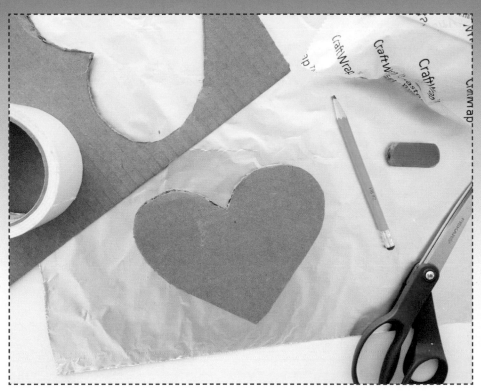

STEP 2

Have your child draw a heart on sturdy cardboard. The heart we created measures 6½" x 5". The shape of your heart can be larger or smaller—it's up to you and your kids!

Once your kids are happy with the shape and size of the heart, help them cut it from the cardboard using scissors or a utility knife.

STEP 3

Crumple strips of foil to form wads and "fill" the interior of the heart. The foil should go all the way to the edge of the heart. Press down on the foil to level the pieces to a consistent height. We used four child's-fist-sized wads of foil to "fill" our heart.

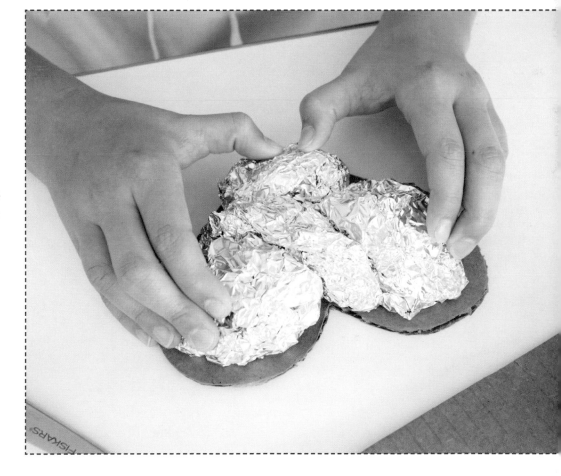

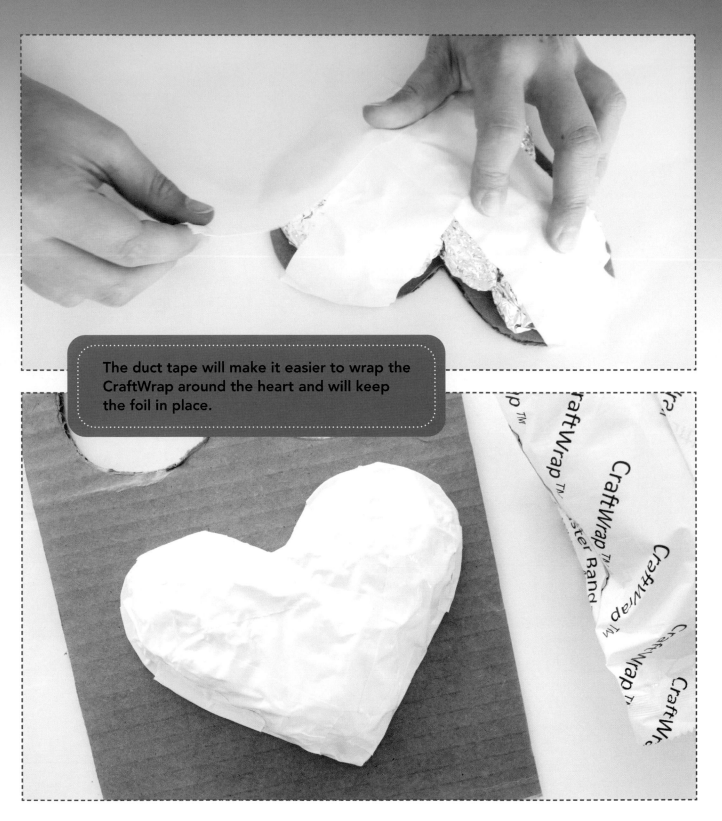

The duct tape will make it easier to wrap the CraftWrap around the heart and will keep the foil in place.

STEP 4

Wrap duct tape around the heart to hold the foil in place. Have your child wrap the duct tape as smoothly as possible around the entire heart, pulling tightly from edge to edge until all of the foil is covered.

STEP 5

Complete this step on top of wax paper so that the heart does not stick to your work area. Cut about a dozen 1- to 1½-inch strips of CraftWrap. It is easier to work with small pieces and cover the heart one section at a time. Dip each strip of CraftWrap in water, making the CraftWrap completely soft so that your child can mold and form it around the heart.

Smooth out each CraftWrap strip with wet fingers. Repeat until the entire heart is covered, including the back.

Let the heart dry and harden completely for about 24 hours on a clean sheet of wax paper. Flip the heart halfway through the drying time to help it dry and harden on both sides.

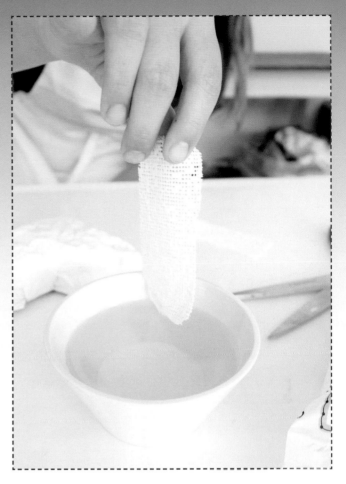

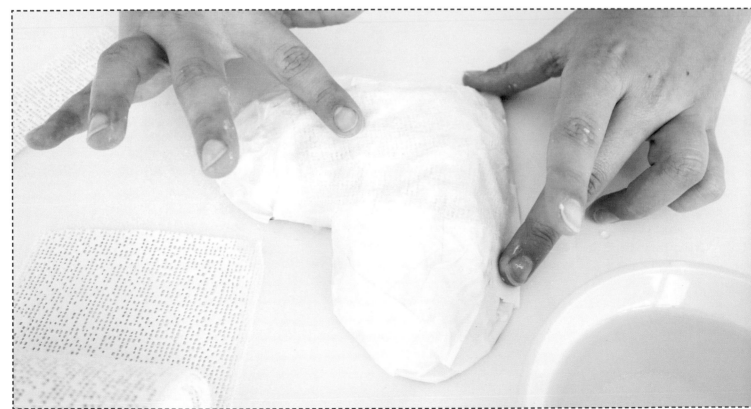

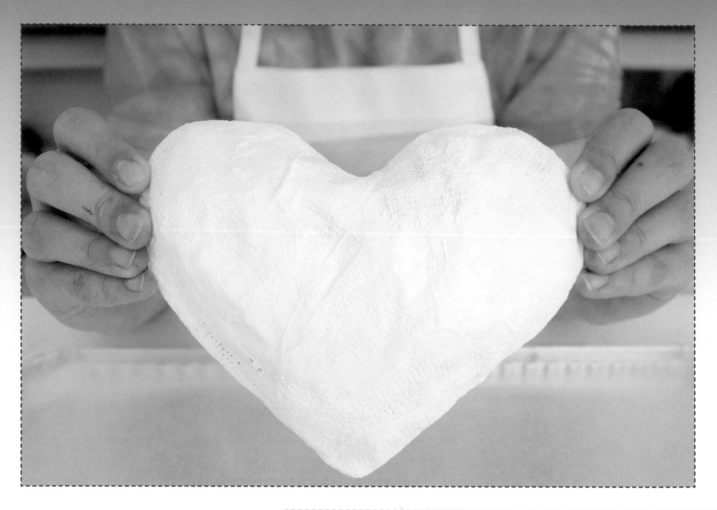

STEP 6

Help your child lay a sheet of wax paper on a foil tray, and place the heart on top of an upside-down cup. This will ensure that the poured paint runs down all sides and edges of the heart.

Help your child pick out paint colors and pour them into individual cups. Have your child add pouring medium to each cup of paint, following a ratio of 2½ parts pouring medium to 1 part paint. Add a small splash of water and mix thoroughly, ensuring that there are no clumps. Replace the water with rubbing alcohol or dimethicone if your child wishes to create more cells in their artwork.

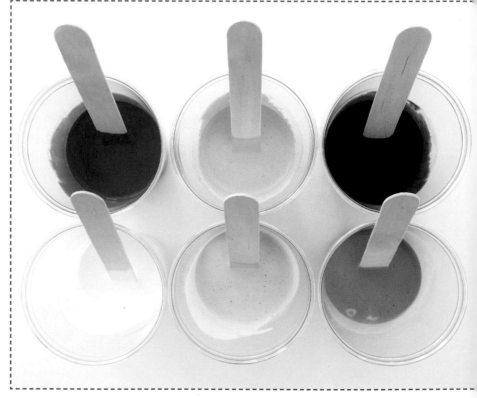

STEP 7

Now help your child create two or three different dirty pour cups by layering the colors (see pages 32-39 to learn how to create a dirty pour). We made each dirty pour cup different so that each section of the heart would look different.

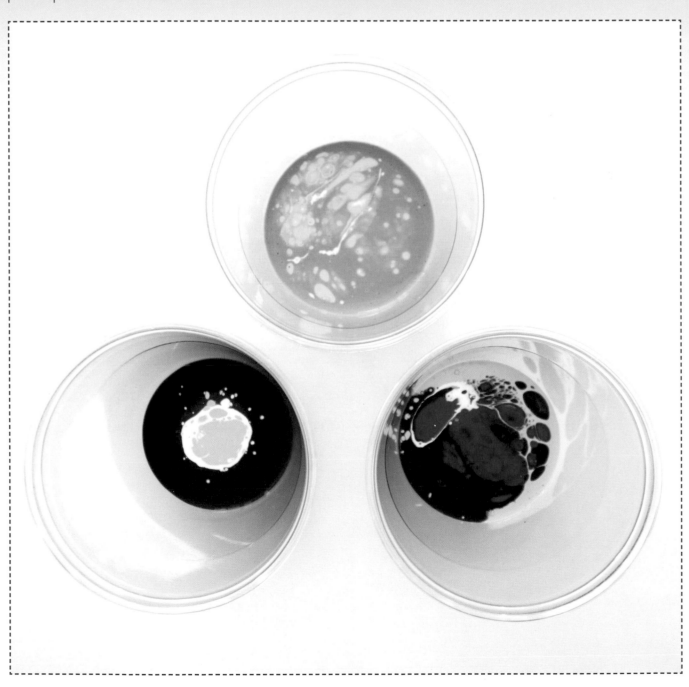

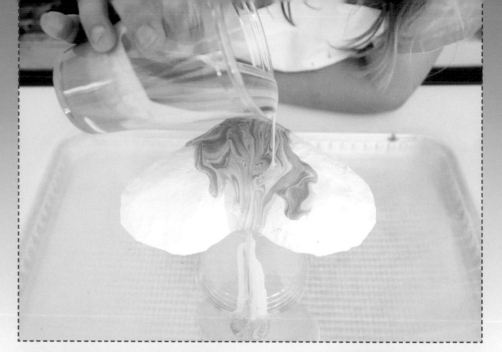

STEP 8

Pour each cup of paint onto the heart, one at a time. You may not need to do any tipping or tilting after pouring the paint; you can let the shape of the heart control the paint flow.

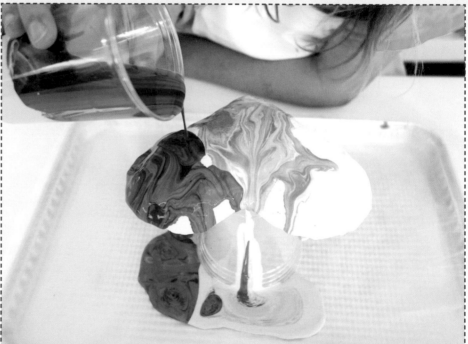

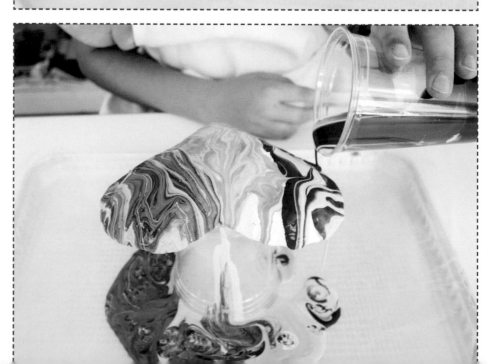

STEP 9

This step is optional, but we found that sprinkling glitter on the heart helped neutralize the texture created by the CraftWrap. Have your child put a small amount of extra-fine glitter into their palm and lightly and evenly sprinkle glitter all over the heart, without allowing it to clump.

Let the heart dry completely on top of the cup for 24 to 36 hours. Once the heart is completely dry, it can be used as a desk accessory, or you can press or lightly hammer a sawtooth hanger into the back of the heart to hang it on a wall.

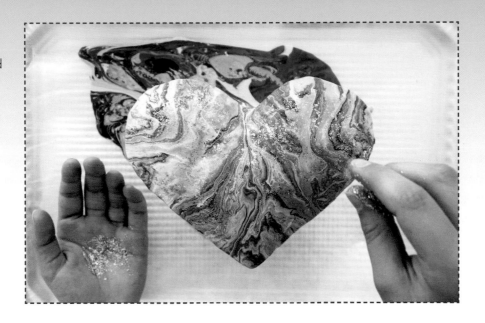

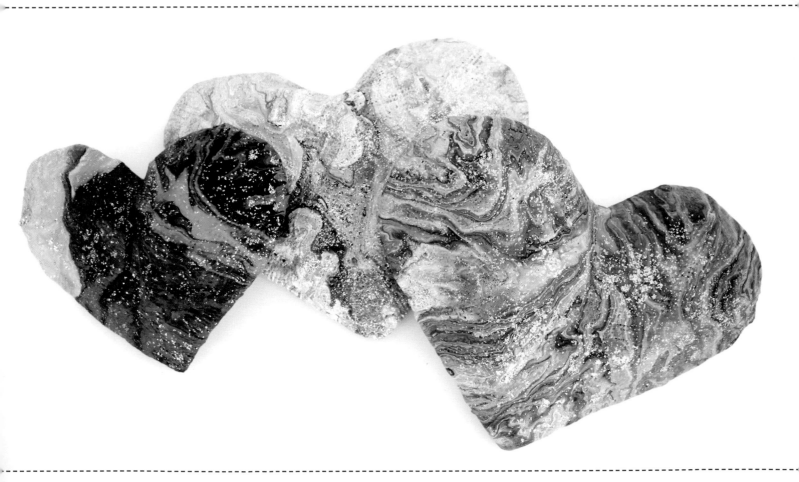

POPSICLE ART

Kids are going to love making acrylic skins! Here, your child is strongly encouraged to think outside the box and create the coolest and wildest popsicles imaginable. Use a dirty pour flip cup technique in this project with very little paint; your acrylic skins do not need to be big. It is important to remember not to mix too many dark colors in your pours, or your popsicles may turn out too dark or muddy-looking. This project will require additional time to complete because acrylic skins can take 36 to 48 hours to dry completely.

Tools & Materials

- Wax paper or vinyl tablecloth
- Baking sheet or foil tray
- Silicone baking mat
- Cups
- Acrylic paint
- Pouring medium
- Water, rubbing alcohol, or dimethicone
- Wooden stir sticks
- Canvas or wood surface
- Ruler
- Paintbrushes in various sizes
- Scrap paper
- Pencil and eraser
- Scissors
- Scrapbook paper
- Mod Podge glue

STEP 1

Have kids prep their workspace by laying down a sheet of wax paper or a vinyl tablecloth. If using a baking sheet, line it, including the edges, with wax paper to protect it from paint. Lay a silicone mat on top.

Pour a small amount of each paint color into a separate cup; then add pouring medium. We used 2½ parts pouring medium to 1 part paint. Add a small splash of water and mix thoroughly, ensuring that there are no clumps. If your child wishes to add cells to their designs, replace the water with a splash of rubbing alcohol or 1 or 2 pumps of dimethicone in each paint cup. Mix thoroughly.

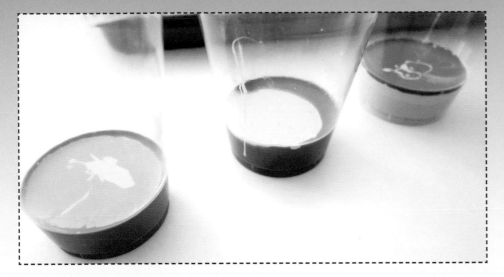

STEP 2

Now your child can create two or three different dirty flip cups. We added a little bit of white to each cup and then a combination of the prepared colors.

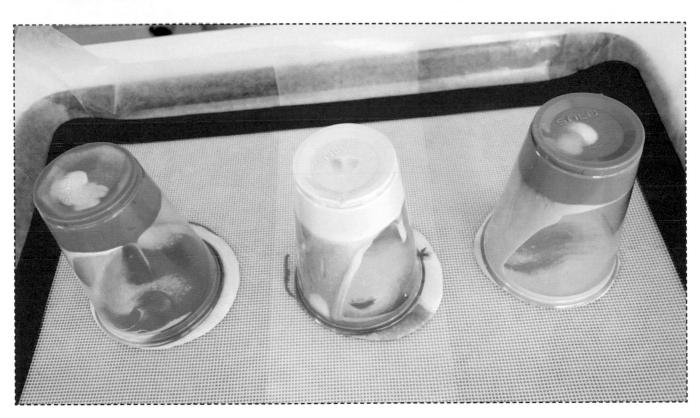

STEP 3

Using the flip cup technique (pages 40-45), apply the paint to the silicone mat. Flip each cup onto the mat, one at a time; then let them sit upside down until all three cups are on the mat.

STEP 4

Gently remove each cup, slowly releasing the paint.

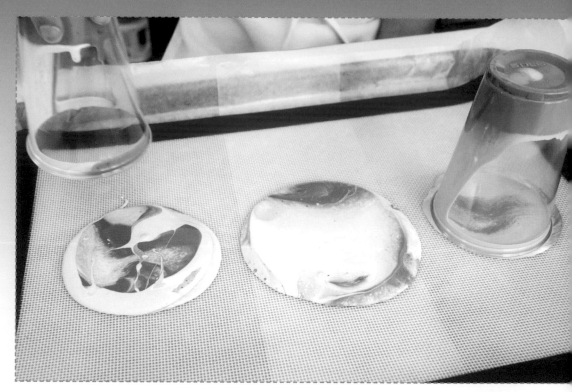

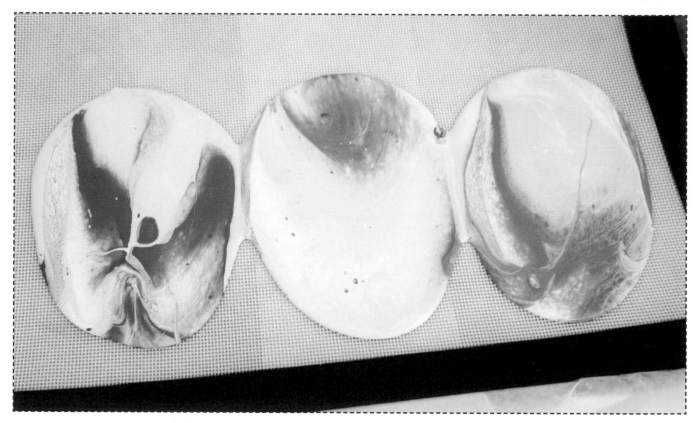

STEP 5

Help your child pick up the baking sheet, tilting and tipping it to allow the paint to flow and cover more of the silicone mat. Remove any noticeable globs of paint with a toothpick.

STEP 6

Set the baking sheet aside on a flat surface and let the acrylic skins dry for 36 to 48 hours.

Once the skins are completely dry, gently lift them from the silicone baking mat.

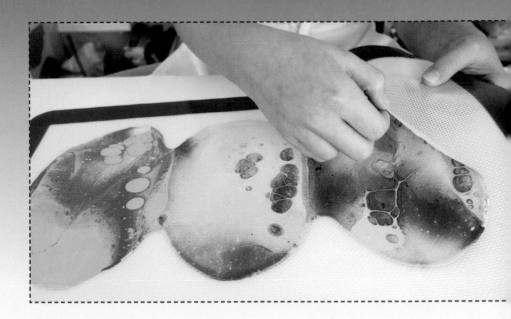

STEP 7

We chose to create a geometric pattern and color blocks for our background.

Using a ruler, mark the areas you wish to divide with a pencil, and start painting. Let the background dry completely before moving on to the next step.

STEP 8

Cut a popsicle shape from scrap paper; then trace the shape onto the acrylic skins.

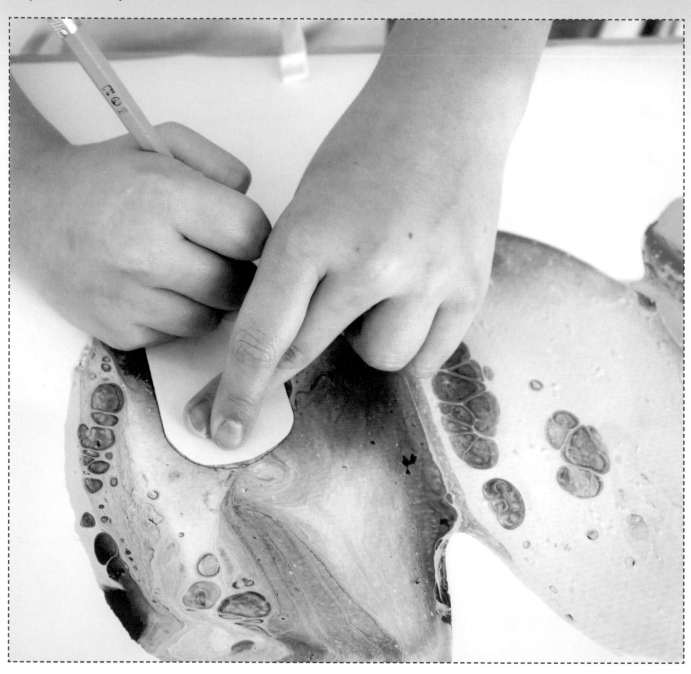

STEP 9

Cut popsicle shapes from the acrylic skins and place them on the surface to play around with the layout. Then help your kids cut out popsicle sticks from scrapbook paper. Once you're happy with the layout, it's time to glue all of the pieces in place!

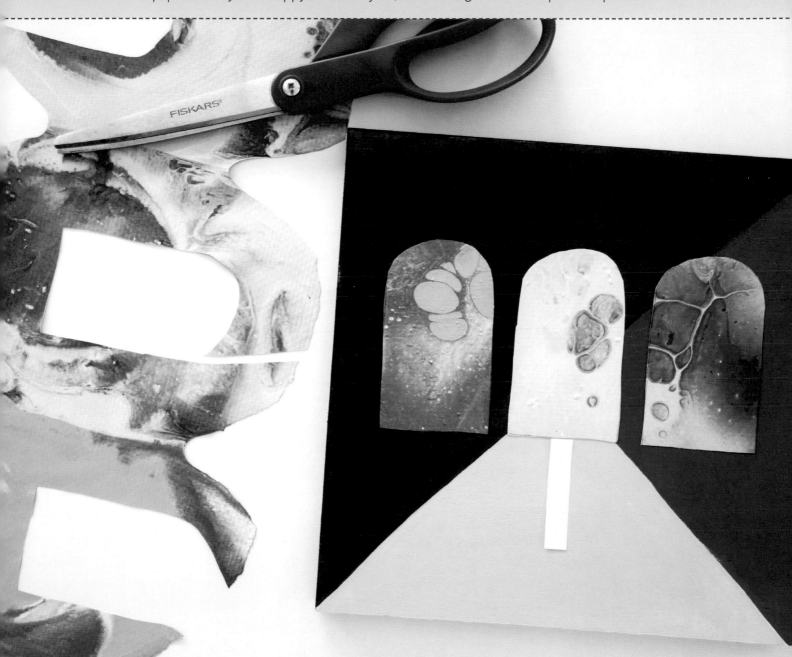

STEP 10

Mod Podge glue works best when applied under and over artwork. Have your child gently lift each piece, one section at a time, gluing down each popsicle and then the sticks. Then brush a thin layer of Mod Podge over the surface, and your child can use their fingers to press down and smooth out any air bubbles. The glue will dry completely clear.

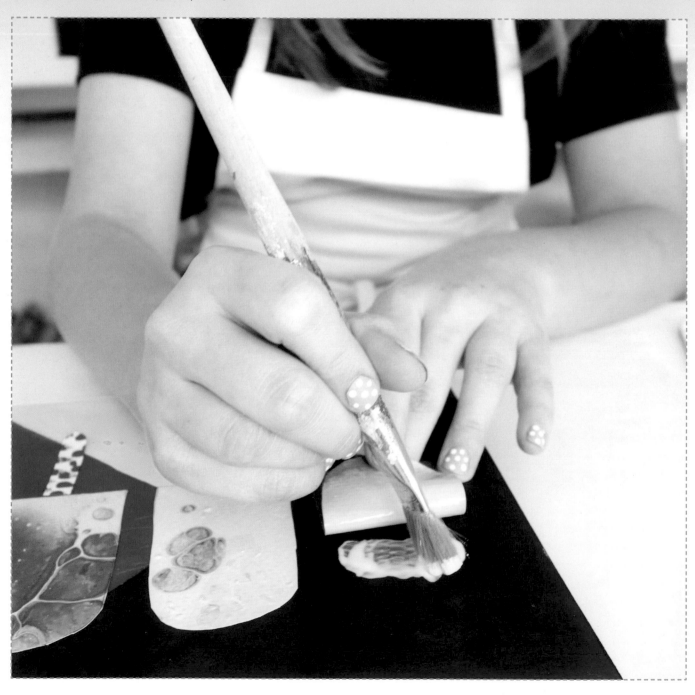

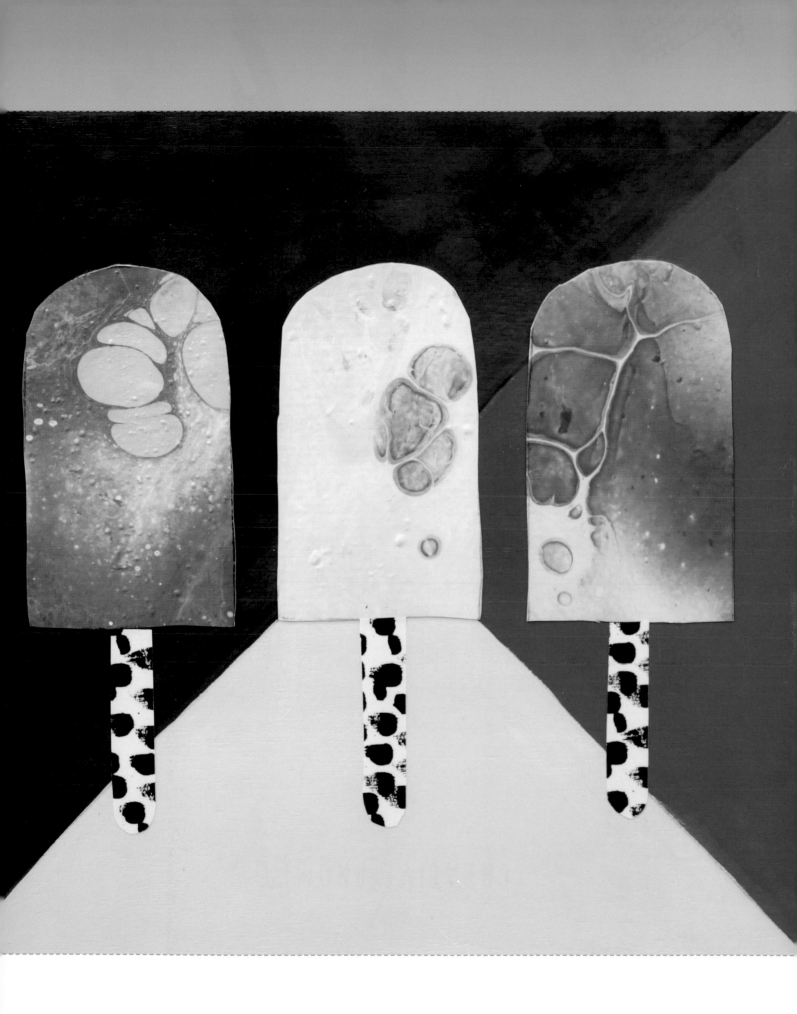

STEP-BY-STEP PROJECT

HEY, BIRDIE, BIRDIE

In this project, you and your child will create a fluid-art painting, and then add a painted object on top of it! My kids and I loved creating our birds on a wire. We intentionally chose light colors for the background fluid art so that the birds would look bold and vibrant. Allow extra drying time to complete this project; the painting must be completely dry before adding the birds. Let's get started!

TOOLS & MATERIALS

- Foil tray
- Wax paper
- Canvas
- Optional: masking tape for the back of the canvas
- Cups
- Acrylic paint
- Pouring medium
- Water
- Wooden stir sticks
- Pencil and eraser
- Scrap paper
- Scissors
- String (approximately 10 to 12 inches long)
- Paint palette or paper plate
- Small- to medium-sized paintbrushes

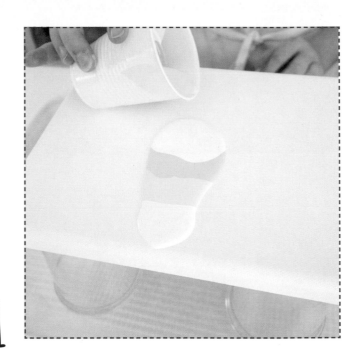

STEP 1

Set up your creative space by covering a tray with wax paper and placing the canvas on cups. Then have your child pour the paint colors into individual cups. Add pouring medium to each cup of paint, following a ratio of 2½ parts pouring medium to 1 part paint. Add a small splash of water and mix thoroughly, ensuring that there are no clumps. Then your child can pour the paint mixtures directly onto the canvas.

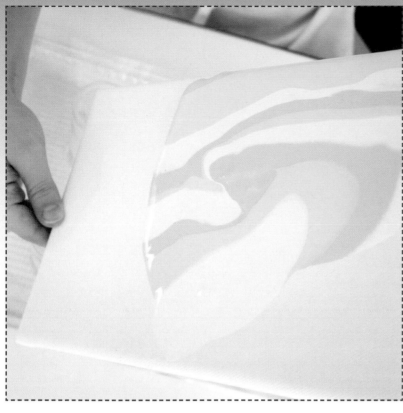

STEP 2

Now your child can tip and tilt the canvas to spread the paint. Once you are happy with the pattern, set the canvas back down on the cups.

STEP 3

If you see uncovered areas or corners of the canvas, have your child pour any leftover prepared paint on those spots and tip and tilt again as needed. A toothpick can be used to remove any noticeable clumps of paint. Lay the canvas back on the cups or leave it in the tray to dry completely for 24 to 36 hours.

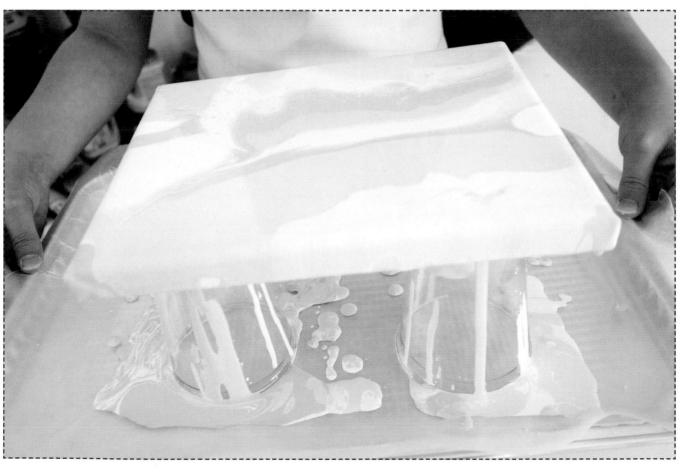

STEP 4

Using a piece of scrap paper, draw a simple bird silhouette. Avoid making the tail and lower wings too thin, as you will need to cut out the bird once you're happy with its shape.

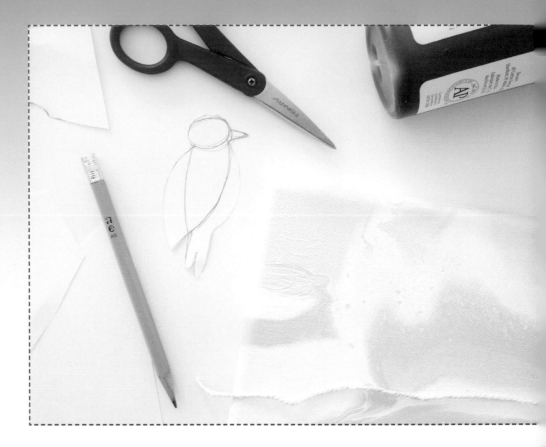

STEP 5

Squirt black paint into a long, rectangular shape on a palette or paper plate and run the string through the paint, covering as much of the string as you can. You don't want the paint in a glob on the string; coat the string evenly so that you can transfer the paint to the canvas. Angle the string slightly across the canvas and press down on each side to leave a "wire" across the canvas. Let the paint dry completely.

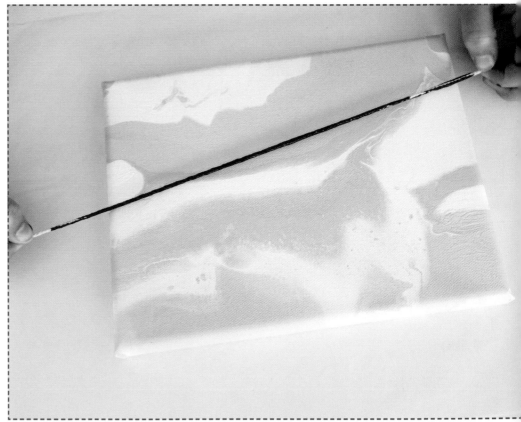

STEP 6

Using the cutout bird silhouette, your child can trace the bird shape onto the wire. The canvas size will determine how many birds fit across it. Alternate the direction of the birds by flipping over the silhouette and tracing it onto the canvas facing in the opposite direction.

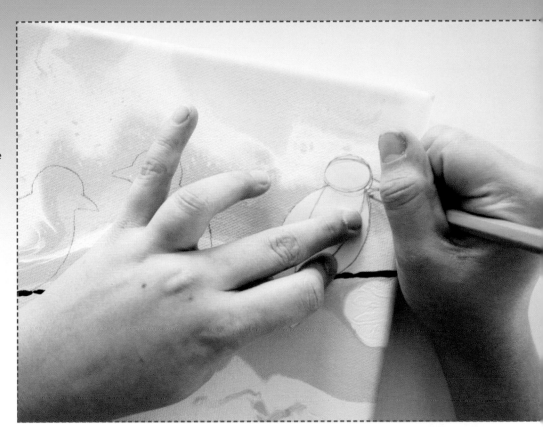

STEP 7

Now that your birds are lined up on the canvas, it's time to fill them with paint! I recommend using a small- to medium-sized brush to paint the birds' bodies and a smaller, fine-point brush to fill in the beak and tail. You and your child can use a wide variety of vibrant colors to fill in the birds—dive in and be fearless!

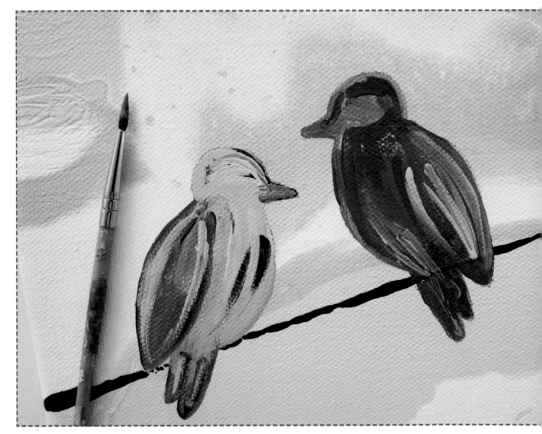

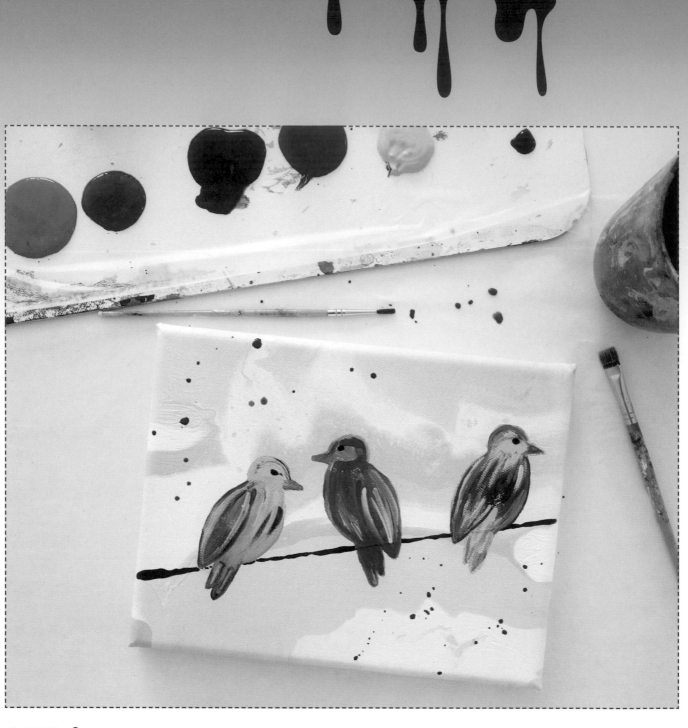

STEP 8

Your masterpiece is almost complete! Add a single dot of paint for the birds' eyes, as well as a few splatters of slightly watered-down paint by gently tapping the tip of a brush over areas of the background. Do this last step when the birds are completely dry so that you can quickly wipe off any areas where you don't want splatters.

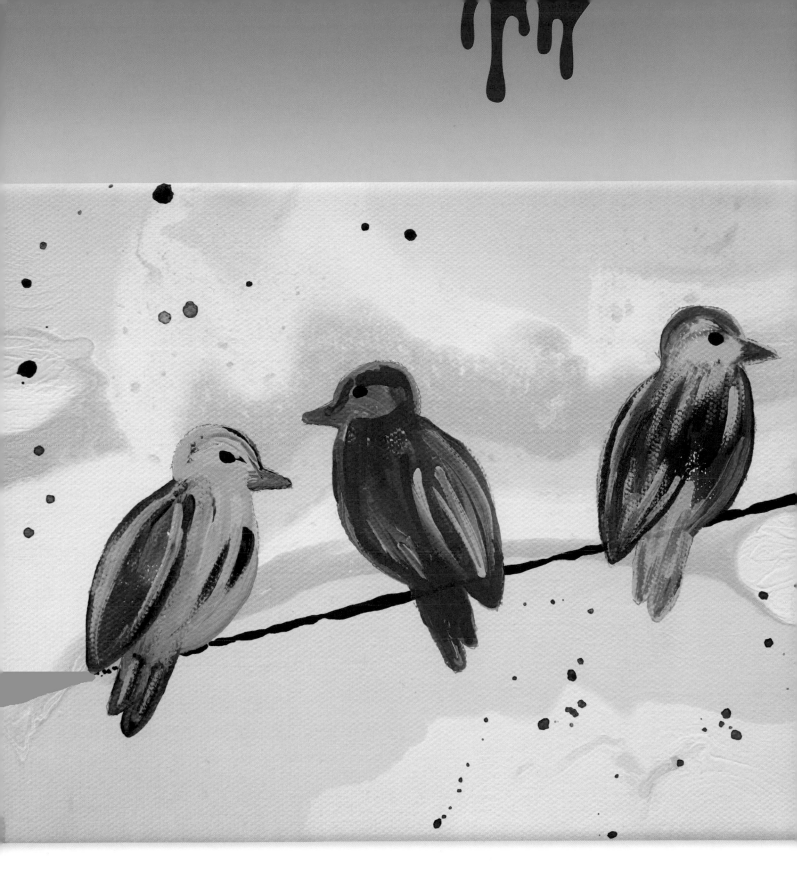

THE UNEXPECTED

This creative prompt is designed to inspire kids to think creatively about all the different ways they can make marks using just one tool or object. Exploring the different ways that a single tool can be flipped upside down, used sideways, rolled on its edge, slid across a surface, or dabbed onto paint will open a whole new world of visual possibilities for your child and give you both a new way of looking at that object. Whether the tool is a rough sponge, comb, bottle cap, palette knife, used gift card, or stiff bristle brush, your child will learn to experiment and explore with just one object while making different types of paint marks. Challenge kids by giving them a specific number of marks to create!

Help your child pick out a safe (and fun!) item to use in this exercise. Whatever you choose, keep in mind that the object of this exercise is to get paint all over your tool, and it may need to be rinsed off a few times if your child uses multiple paint colors.

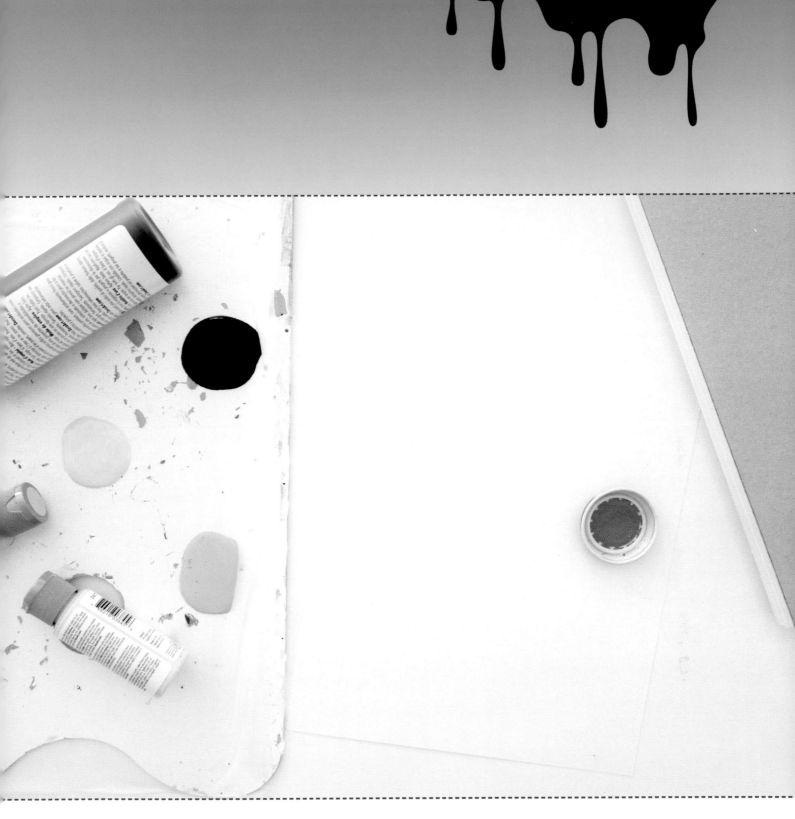

Set up your creative space by laying a sheet of wax paper or a vinyl tablecloth on your work surface with a piece of scrap paper on top. Next, have your child choose a few different paint colors and squirt them on a paint palette or paper plate. With their tool of choice in hand, kids are ready to start making marks on the paper.

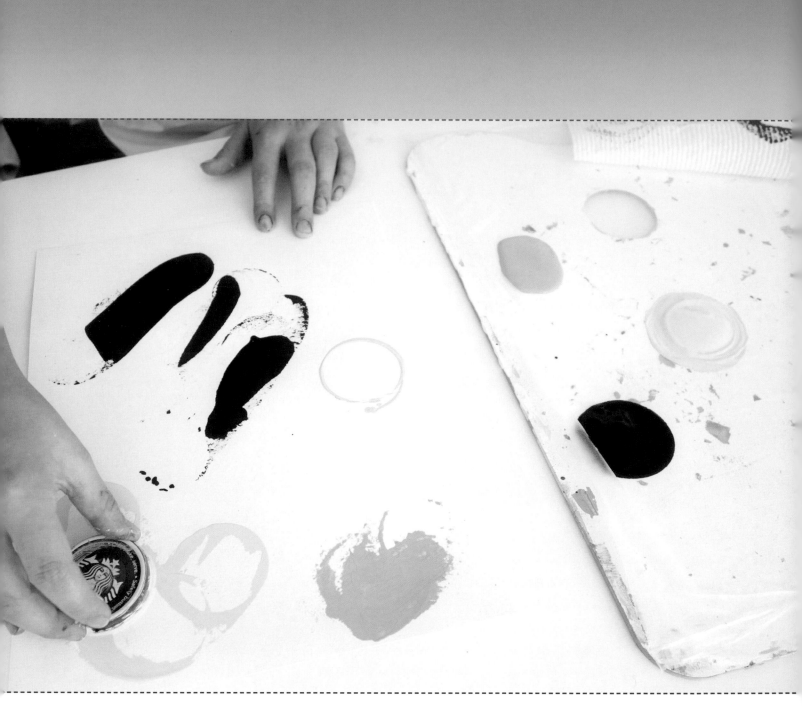

Encourage your child to slide, tilt, flip over, lay flat, dab, and roll the object in paint and then onto the paper to create unique, unexpected marks. Your child can fill up the paper using different paint colors and washing or wiping the tool in between colors as needed.

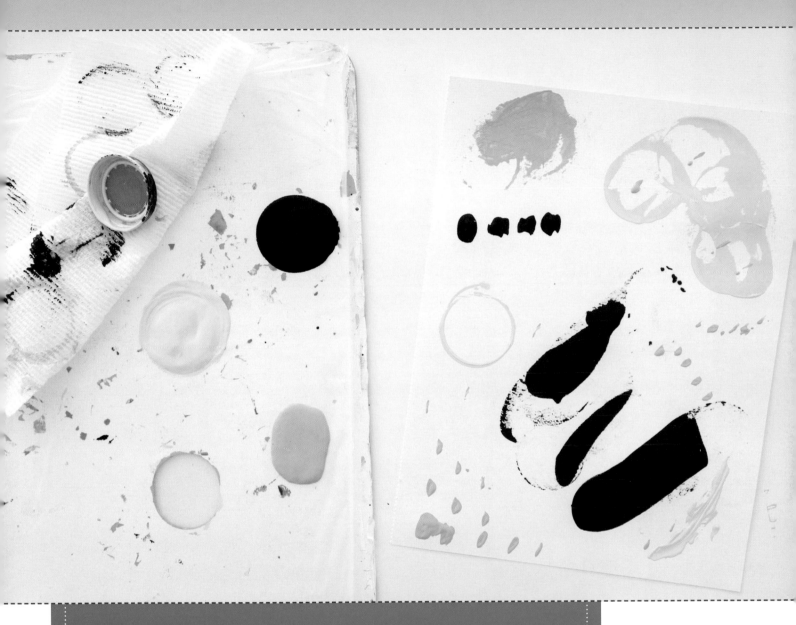

When kids are finished, ask them what their favorite paint marks are or which way they most enjoyed using the tool.

GIFT IT! CREATIVE PACKAGING

There's nothing like gifting an original work of art, and for me, presentation is everything! These papier-mâché boxes come in all shapes and sizes. It can become quite addicting to play around with color combinations and pouring techniques! Adding a sprinkle or two of extra-fine glitter will make your packaging extra special.

TOOLS & MATERIALS

- Papier-mâché box
- Vinyl tablecloth
- Wax paper
- Foil tray
- Cups
- Acrylic paint
- Pouring medium
- Water, rubbing alcohol, or dimethicone
- Wooden stir sticks
- Optional: extra-fine glitter
- Scissors or utility knife
- Spray varnish

STEP 1

Help your child set up the creative space by laying down a vinyl tablecloth and lining a foil tray with wax paper. Lay the papier-mâché lid and box facedown on the wax paper.

Then your child can pour paint colors into separate cups. The size of your box will determine the amount of paint needed. For the size we used, we needed about 5 ounces of paint total (see step 2).

Have your child add pouring medium to each cup of paint for a ratio of about 2½ parts pouring medium to 1 part paint. Add a small splash of water and mix thoroughly. Use rubbing alcohol or dimethicone instead of water if your child wishes to create more cells in the artwork.

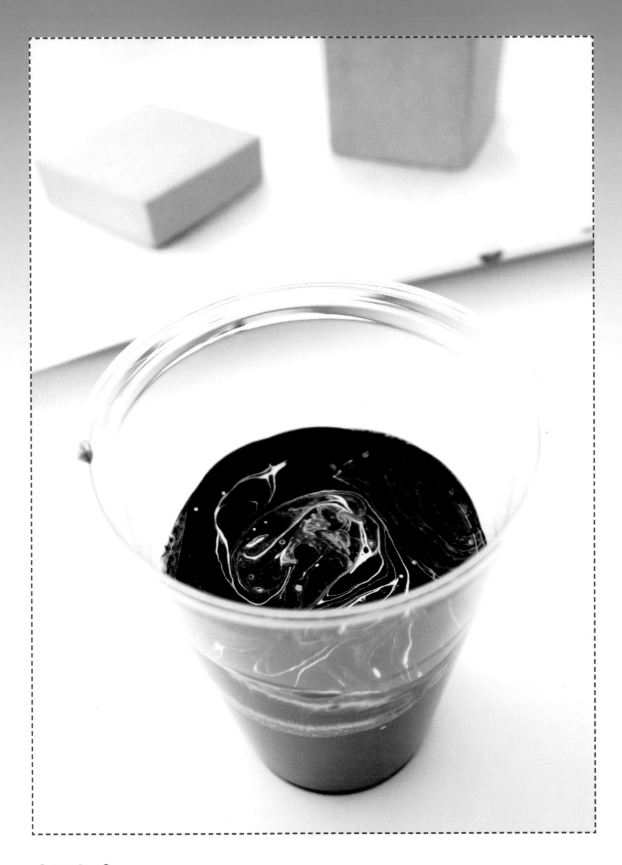

STEP 2

Help your child create a single dirty pour cup, layering the colors a little at a time until you've used most of the paint in the cups.

STEP 3

Now your child can begin pouring paint over the largest part of the box, making sure there's enough paint to cover the rest of the box too. If it's helpful, your child can go back and forth between the parts of the box, pouring a little on each area until the entire box is covered. We didn't need to tip and tilt the box once the paint was poured; we simply let the paint flow where it wanted. However, your child can certainly tilt and tip the box to modify the pattern a bit!

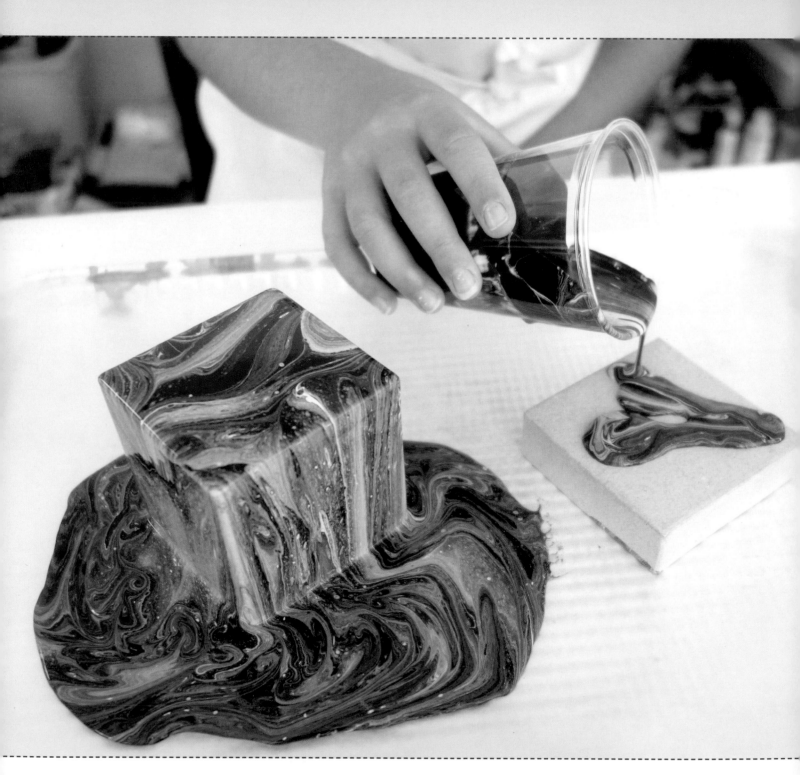

STEP 4 (OPTIONAL)

If your child would like to add extra-fine glitter to the box and/or the lid, it is easier to control the glitter by placing a small amount in the palm of your child's hand and having them lightly sprinkle it over the box.

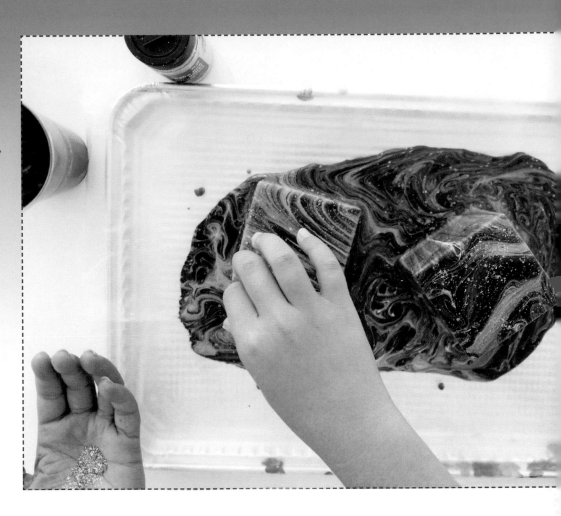

STEP 5

Wait 20 to 30 minutes before carefully touching the tips of two corners of the box and moving it onto a new sheet of wax paper to dry for 24 to 36 hours. If you smudge the paint on the box while moving it, the paint will flow back into place as it dries.

Once the box is completely dry, any excess dried paint on the rim or underneath the box top can be gently removed with sharp scissors or a utility knife.

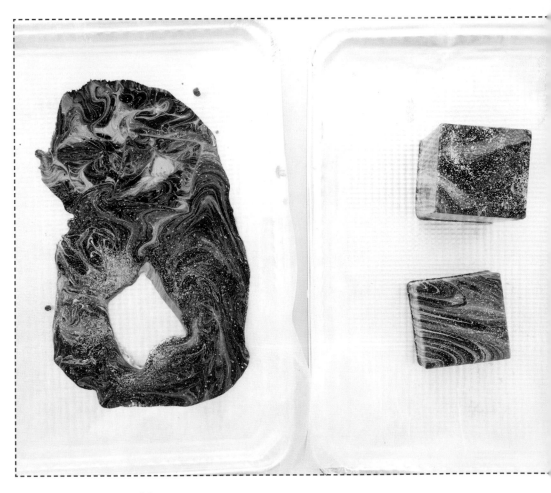

STEP 6 (OPTIONAL)

A coat of glossy spray varnish adds a finished look to these boxes. Anyone lucky enough to receive a gift packaged in your child's artwork will think the box was store-bought!

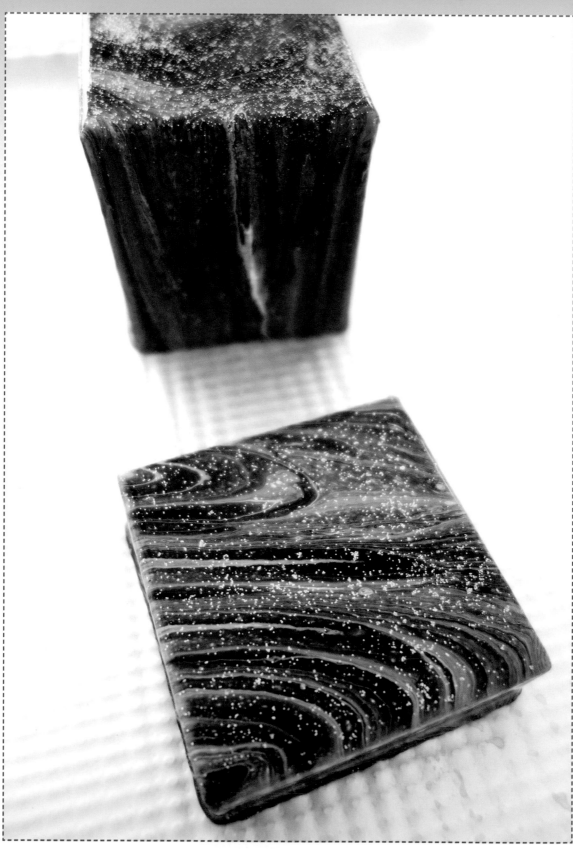

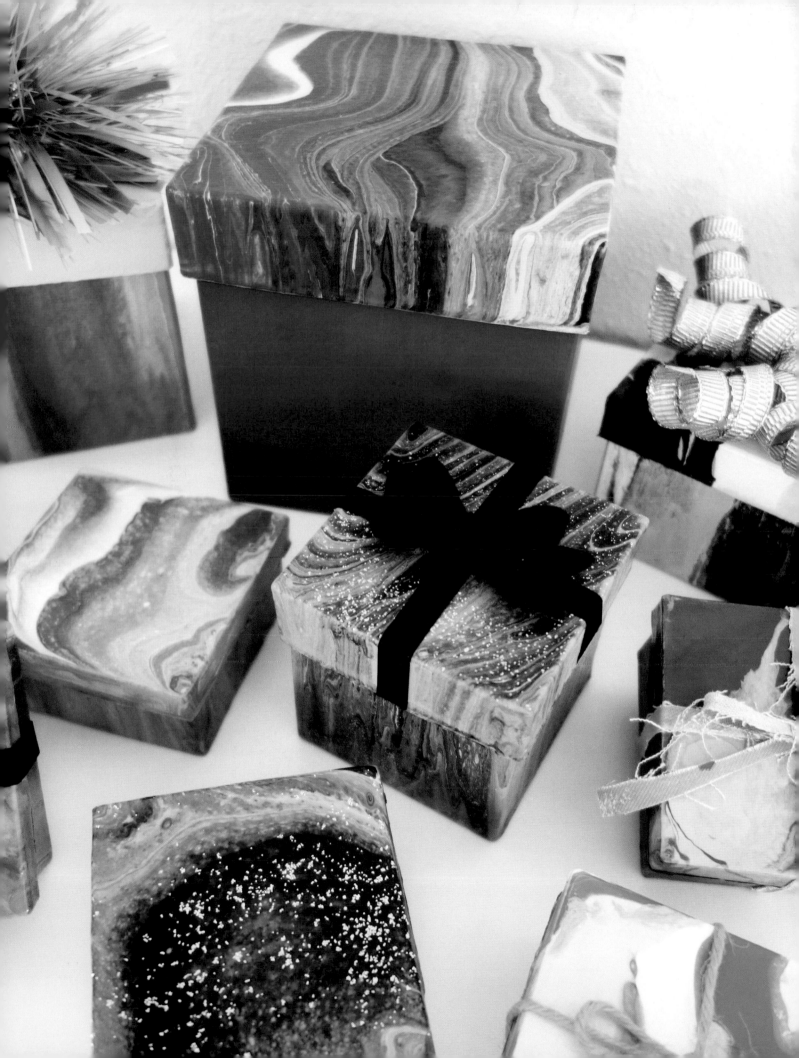

WOOF! MEOW! MIXED-MEDIA ANIMAL COLLAGE

Why not have your children create their very own depiction of a family pet using a custom-poured paint skin? A dirty flip cup technique is used in this project along with very little paint since the pet can be small. Encourage your child to be creative! A pink cat? How fancy! A blue dog? So brilliant! This project will require additional time to complete because acrylic skins can take 36 to 48 hours to dry completely.

TOOLS & MATERIALS

- Wax paper or vinyl tablecloth
- Silicone baking mat
- Cups
- Acrylic paint
- Pouring medium
- Water or rubbing alcohol
- Wooden stir sticks
- YUPO Heavy paper
- Scrapbook paper
- Scissors
- Mod Podge glue
- Paintbrushes in various sizes

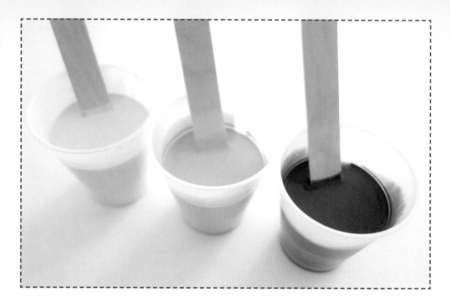

STEP 1

Have your child prep the workspace by laying down wax paper or a vinyl tablecloth. If using a metal baking sheet under the silicone mat, line the baking sheet, including the edges, with wax paper as well.

With your child, pick out colors to use for the pet. Then pour the paint colors into separate cups, using only a small amount of each color.

Add pouring medium to each cup of paint following a ratio of 2½ parts pouring medium to 1 part paint. Add a small splash of water and mix all thoroughly, ensuring that there are no clumps. If your child wishes to create additional cells in the acrylic skin, replace the water with rubbing alcohol in each color. Mix thoroughly.

STEP 2

Help your child create a single dirty pour cup to flip onto the silicone baking mat. When building a dirty pour cup, it is best to layer the colors. Add slightly more of the color that you wish to see most of; then layer the other colors little by little. Give the paint one gentle stir with a wooden stir stick.

STEP 3

We used the flip cup technique (pages 40-45) to apply paint to the silicone mat. Flip the cup over onto the mat, and watch the paint ooze out. Once most of the paint has poured out of the cup, gently remove the cup and tip and tilt the mat or the baking sheet until the surface is mostly covered and your child likes the pattern. Let the acrylic skin dry completely for 36 to 48 hours.

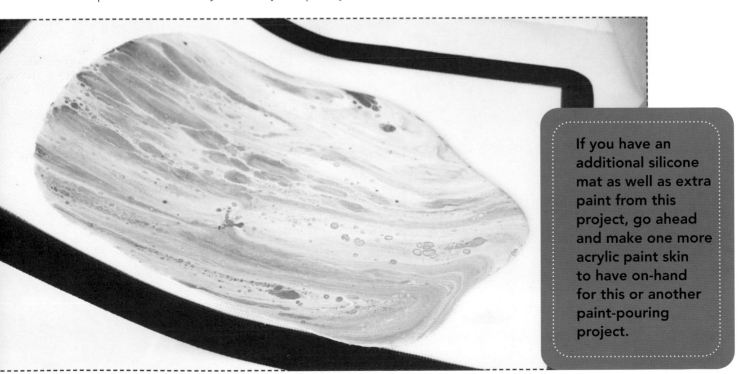

If you have an additional silicone mat as well as extra paint from this project, go ahead and make one more acrylic paint skin to have on-hand for this or another paint-pouring project.

STEP 4

Your acrylic skin should now be completely dry and ready to be gently lifted from the silicone baking mat.

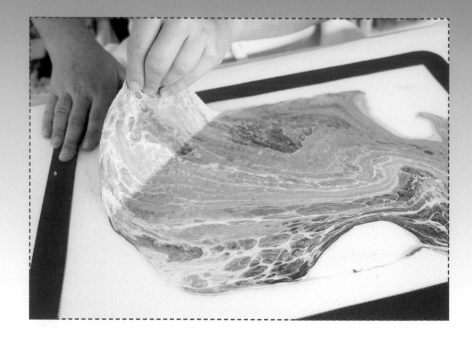

STEP 5

Cut two simple shapes from the acrylic skin to resemble the pet's head and body. Lay them on the YUPO paper until you are ready to glue everything in place. Cut your animal's ears from scrapbook paper and lay them on the paper as well.

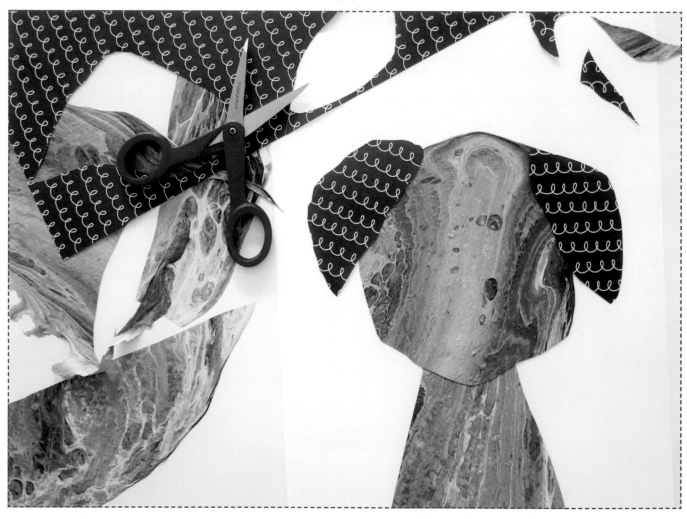

STEP 6

Before gluing down the animal's head, body, and ears, have your child cut out eyes and a nose for the pet; then arrange them on the pet's head. We thought it would be fun to use old dictionary pages, and we also added a collar made from scrapbook paper.

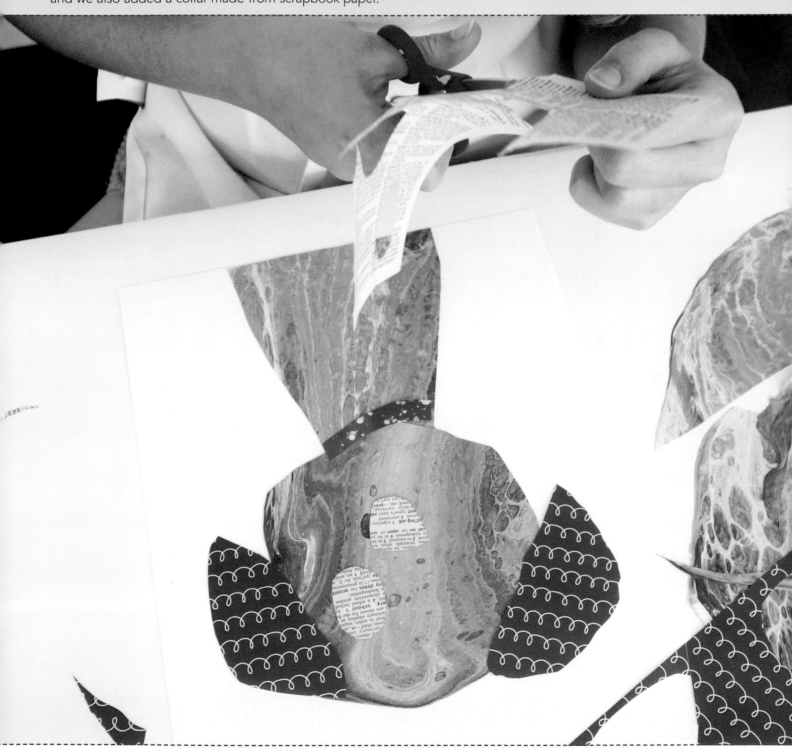

STEP 7

Once your child is happy with the layout of the pet, glue all of the pieces in place. Mod Podge glue works best when applied underneath and on top of an object. Using a paintbrush to apply the glue, help your child gently lift each piece, one section at a time, gluing down the items in the following order: body, head, ears, eyes, nose, and collar. Then brush a thin layer of glue over the entire piece and use fingers to press down any areas that might need smoothing and/or show air bubbles. The glue goes on white, but it will dry completely clear.

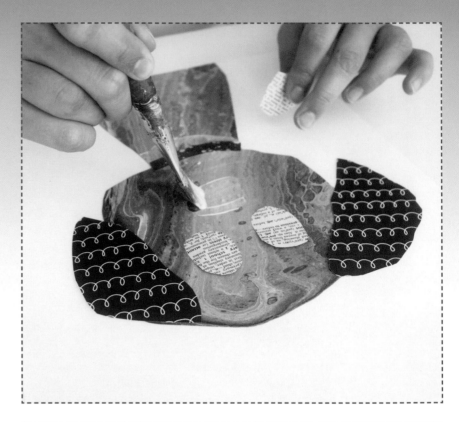

STEP 8

Once all pieces are glued down and completely dry, have your child paint the background of the artwork and add any additional details to the pet's eyes and nose.

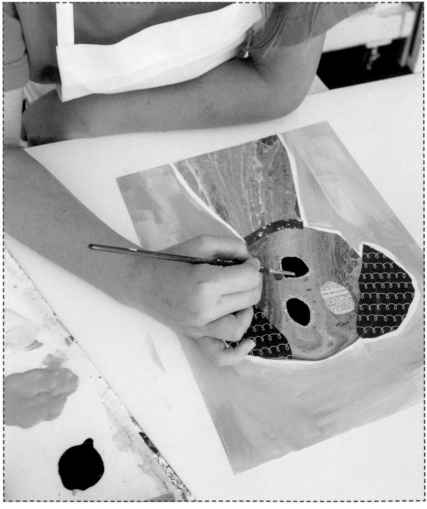

STEP 9

Add finishing touches to the artwork, such as a mark here and there in another color, or a splatter or two on the background. Don't forget to add a touch of white to the eyes and thin lines for the mouth!

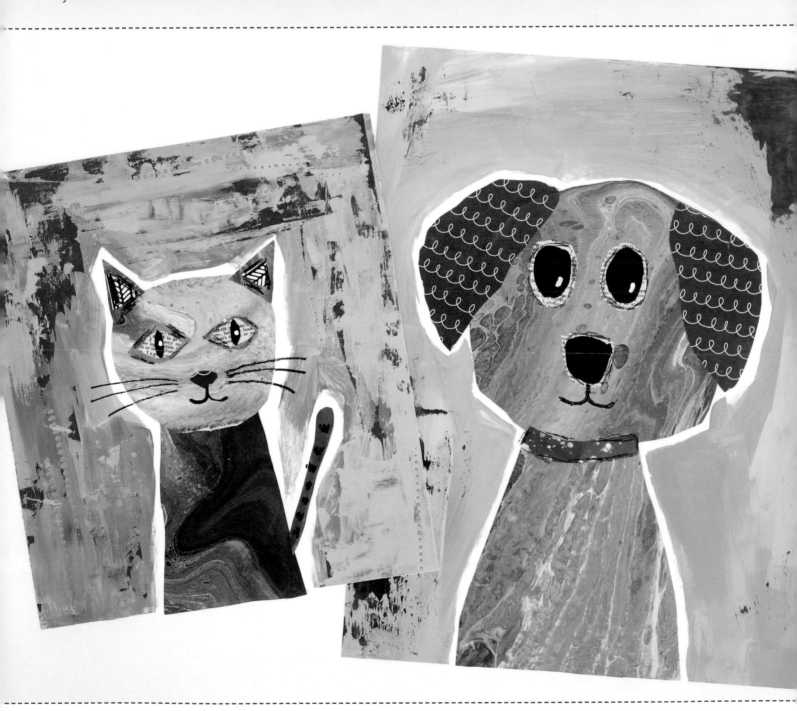

STEP-BY-STEP PROJECT

STONE COASTERS

Coasters featuring fluid art make a fantastic gift for just about any occasion! Not only is each coaster an original work of art, it can also add a touch of color and pure happiness to home decor. Kids will enjoy the simplicity of producing different, but beautiful, results each time using just one set of colors.

TOOLS & MATERIALS

- Wax paper
- Vinyl tablecloth
- Cups
- 4 stone tile coasters (4" x 4")
- Acrylic paint
- Pouring medium
- Water, rubbing alcohol, or dimethicone
- Wooden stir sticks
- Optional: extra-fine glitter
- Spray varnish
- Small, round felt pads

Keep a few blank coasters on hand for any leftover paint pours. Your child might want to create a coaster to keep in their room or to give as a small gift to a friend!

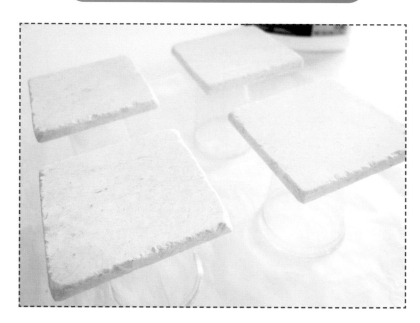

STEP 1

Have your child set up the creative space by laying multiple sheets of wax paper on a vinyl tablecloth. Place four cups upside down on the wax paper, with the coasters on top.

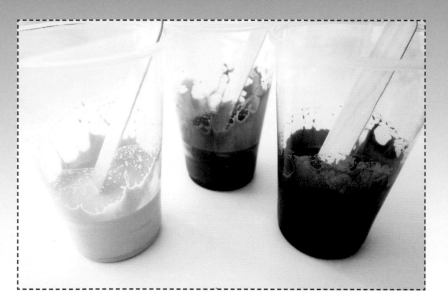

STEP 2

Pour paint colors into individual cups. Have your child add pouring medium to each cup of paint for a ratio of about 2½ parts pouring medium with 1 part paint. Add a small splash of water and mix thoroughly. Use rubbing alcohol or dimethicone instead of water if your child wishes to create more cells in the artwork.

STEP 3

Help your child create four dirty pour cups by layering the colors. Make each cup of paint different so that each coaster pattern will look different.

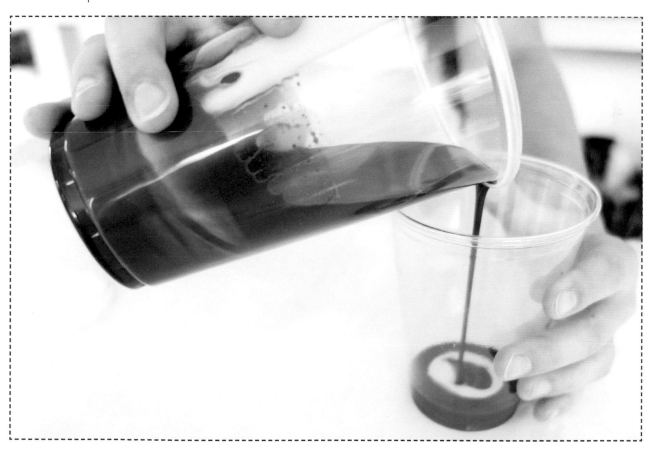

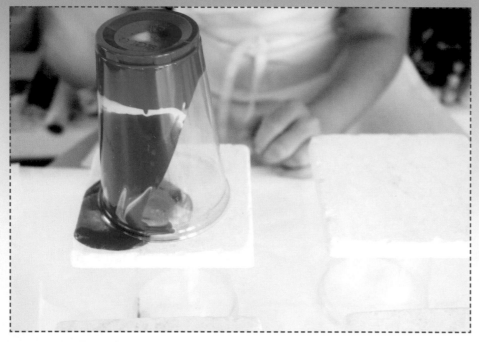

STEP 4

Pour or flip the cups (let your child choose the technique!) one by one onto a coaster. Your child could create one coaster using the flip cup technique and pour paint on another in a zigzag or circle. After pouring paint on the coaster, tip and tilt it to cover its edges. Once your child is happy with the design, set the coaster back on the cup to dry completely.

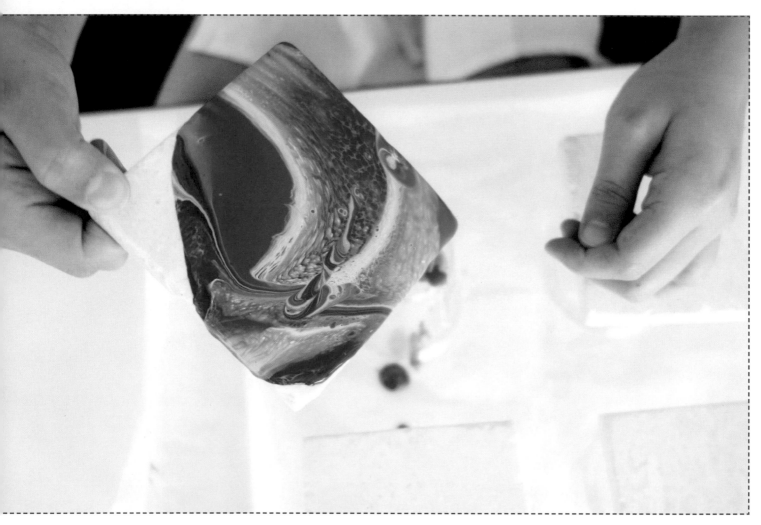

STEP 5

Pour or flip the remaining dirty pour cups one at a
time onto the coasters, tipping and tilting until all of
the coasters are complete. Let the coasters dry on
top of the cups on a flat surface for 24 to 36 hours.

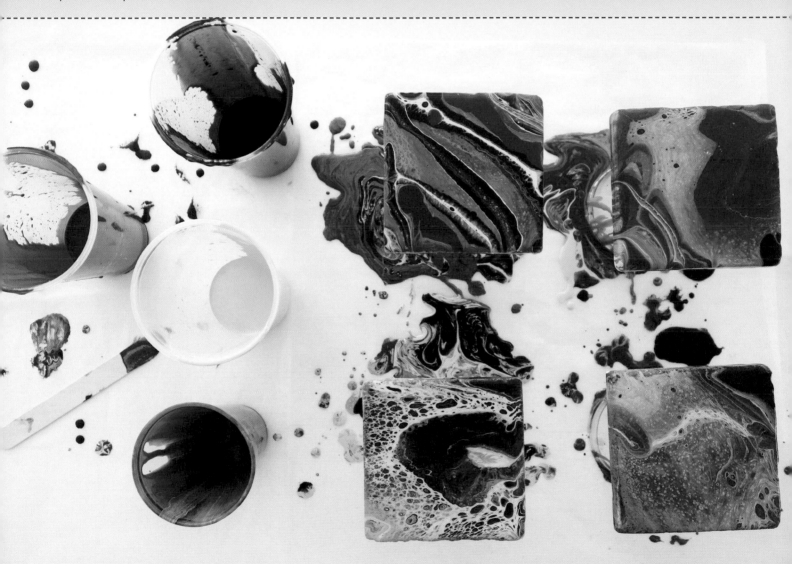

STEP 6

To keep the surface of the coasters from scratching and to maintain the freshness and vibrancy of your child's one-of-a-kind artwork, spray 1 to 2 coats of varnish on the surface of the coaster. Spray varnish only outside or in a well-ventilated area. Don't forget to add small, round felt pads underneath the coasters so they don't scratch your furniture.

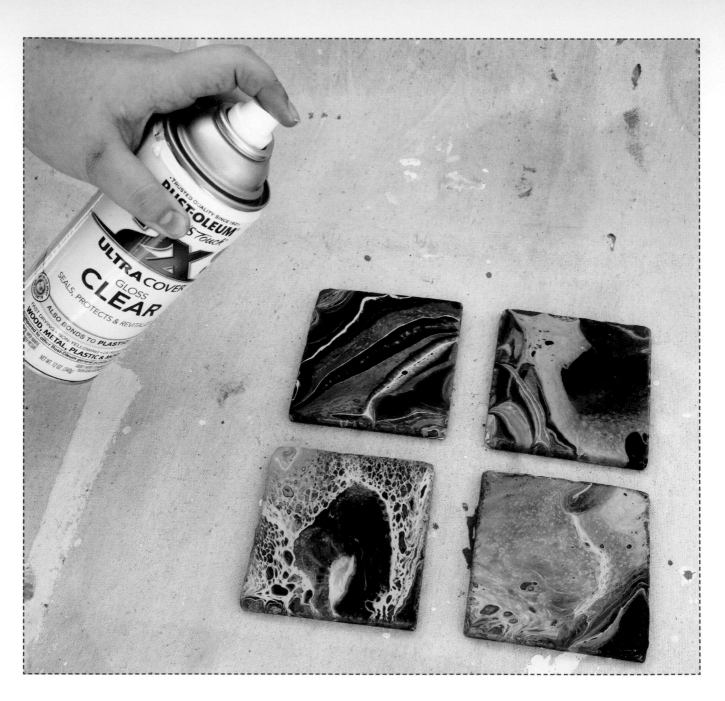

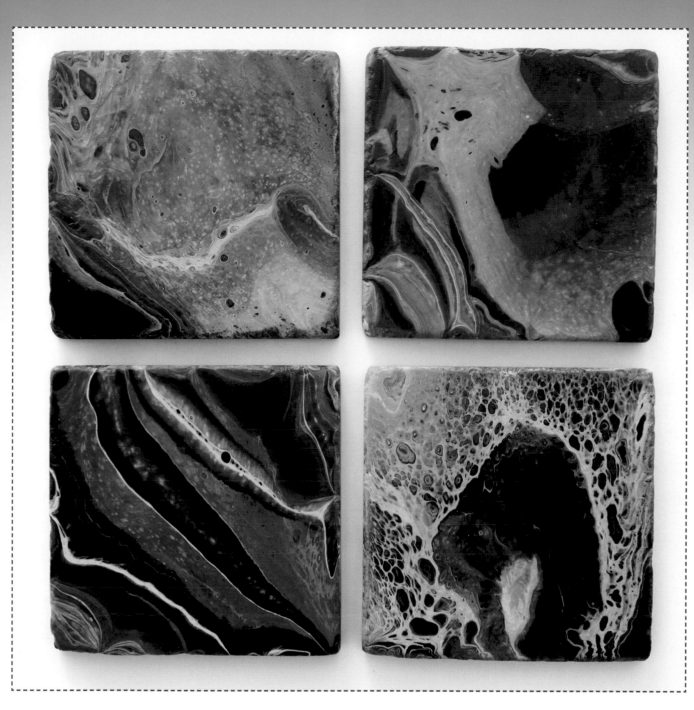

ADD A LITTLE SPARKLE

If kids wish to add a hint of extra-fine glitter to their coasters, make sure they do it lightly. With the coasters complete but still wet, have your child add a small amount of glitter to the palm of their hand. Pinching a bit of glitter and lightly sprinkling it onto a coaster, one at a time, will give your child more control over the glitter placement. Then let the paint dry as usual for 24 to 36 hours before spraying with varnish.

CREATIVE PROMPT

DRIP, FLICK & DOT

This easy creative prompt is sure to inspire your child to want to create. Making random marks with a paintbrush is a fun activity for kids, and there's no need to overthink the process. Encourage kids to get creative using a paintbrush in different ways and by adding more water and paint to the brush. Tapping the end of the brush over the paper will create paint splatters.

Explore galore! There is no right or wrong way to drip, flick, and dot, allowing your children to be as creative as possible!

Have your child set up a creative space by laying down a sheet of wax paper or a vinyl tablecloth with a piece of scrap paper on top. Then your child can choose a few paint colors and dab a bit of each on a paint palette or paper plate.

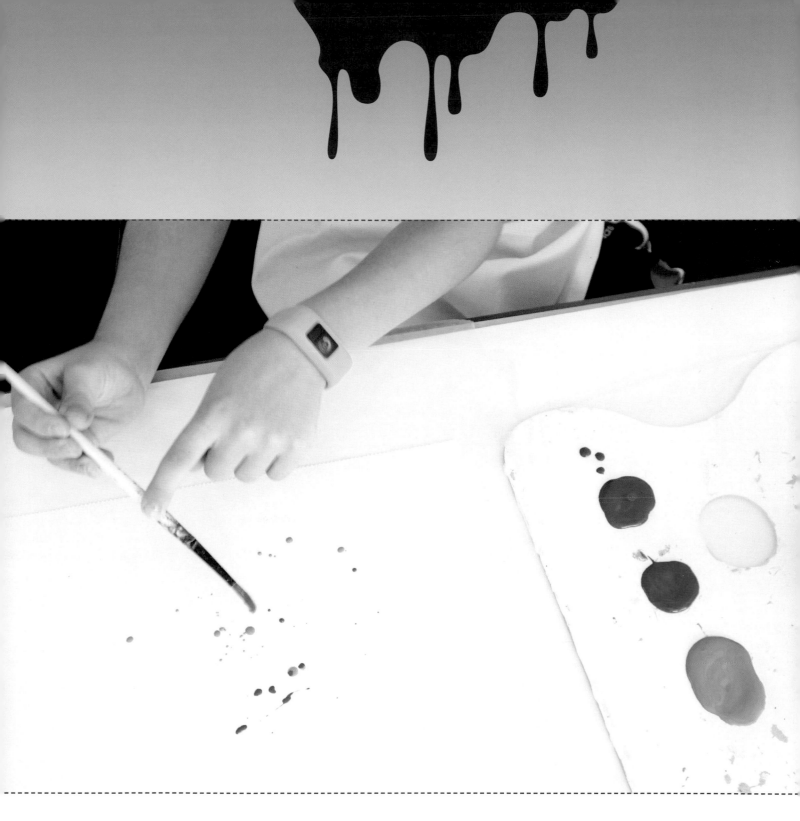

Let the fun begin! Kids can start with whatever marks they wish. This is simply a creative exercise that allows your child to learn and experiment with different ways of using a paintbrush.

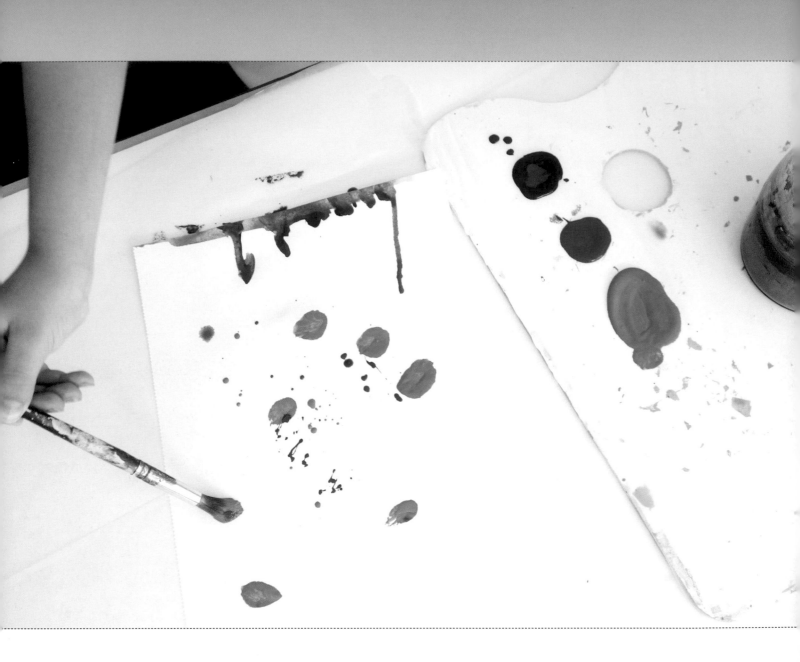

Have your kids fill up the sheet with drips,
flicks, and dots.

This exercise should leave kids inspired to create more!

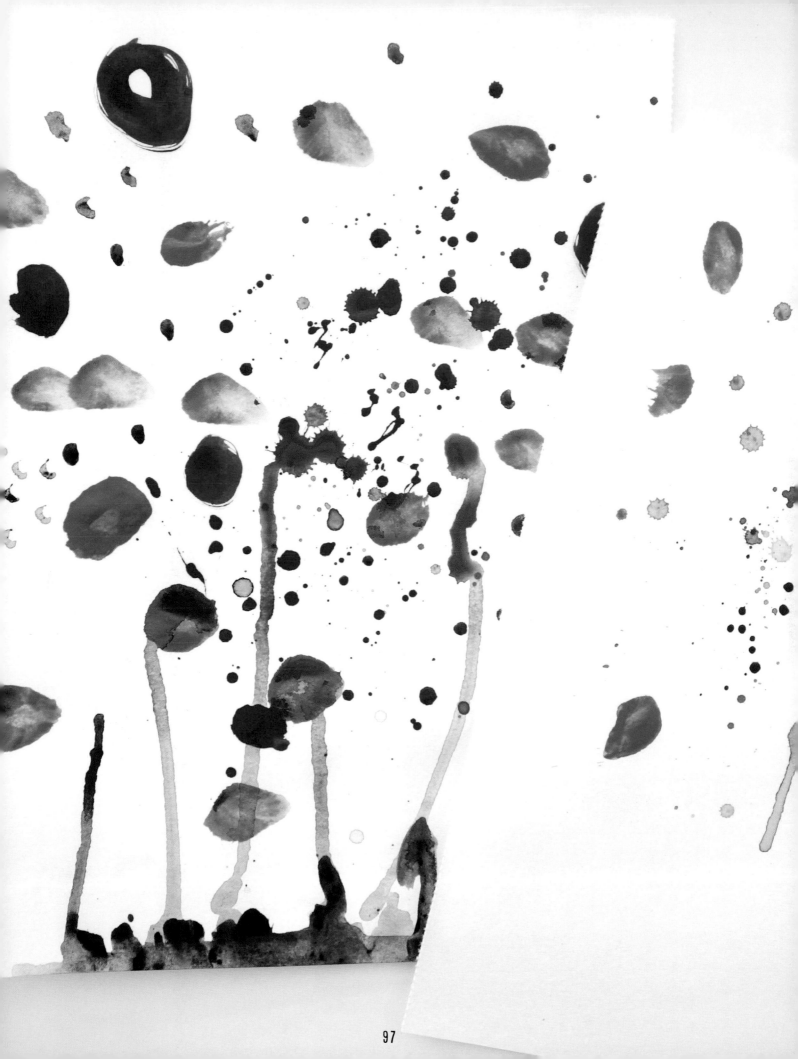

HAPPINESS FROM ABOVE: CLOUD & COLORFUL RAIN

This project offers a unique way to bring paint pouring into a project to be showcased in your child's room or playroom decor! Ideally you have small boxes somewhere that can be used to cut out a cloud and some raindrops—just a few small pieces of cardboard are all you need to get started. Your kids will love creating the colorful raindrops (my favorite part of this project!). Let them go wild with colors—the more, the better!

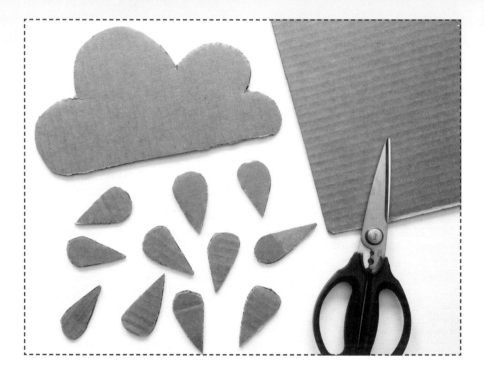

Tools & Materials

- Vinyl tablecloth
- Cardboard
- Pencil
- Scissors or craft or utility knife
- Wax paper
- Foil tray
- Cups
- Acrylic paint
- Pouring medium
- Water
- Wooden stir sticks
- Hot glue gun
- Metal ring hanger
- Clear fishing wire
- Duct tape

STEP 1

Set up your creative space by laying a vinyl tablecloth over your work surface. Then have your child use a pencil to draw a cloud and raindrops on cardboard. Cardboard can be challenging to cut, so make sure you cut out the cloud and raindrops for your child if you choose to use a craft or utility knife.

The raindrops don't have to be identical in shape or size, and you can create as many as you wish.

STEP 2

Have your child line a foil pan with wax paper and set up cups on which to rest the raindrops while pouring paint on them. Then mix the paint to pour onto the raindrops. For our raindrops, we chose to go for a tone-on-tone effect in each raindrop and wanted a rainbowlike look.

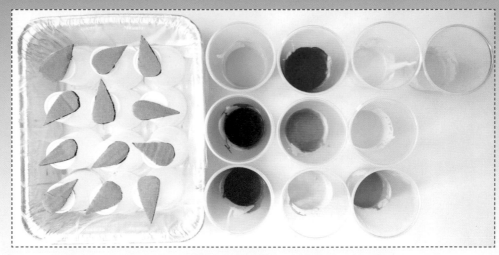

Follow a ratio of about 2½ parts pouring medium to 1 part paint. Add a small splash of water and mix thoroughly with a wooden stir stick, ensuring that there are no clumps in the paint mixture.

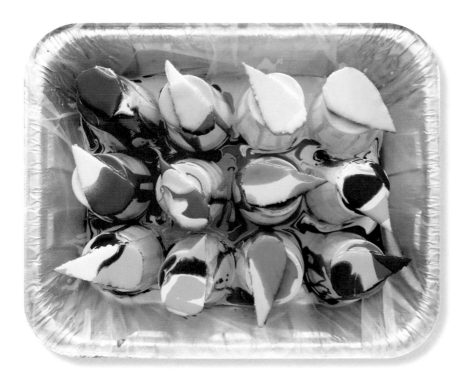

STEP 3

Happiness begins with color! Have your child pour paint onto each raindrop. Because the raindrops are so small, tipping and tilting them isn't necessary—simply layering the colors works just fine! Have your child pour a little bit of each color one at a time on the raindrops. You can add additional colors if you wish to make the raindrops multi-colored. Once all of the raindrops are completely covered and your child is happy with the way they look, set them aside in a safe place to dry for 24 to 36 hours.

STEP 4

Lay the cardboard cloud flat on a sheet of wax paper. Have your child mix the colors for the cloud. Make sure to mix your two colors separately, and you might choose to mix a small cup of gold paint to give your cloud a dreamy, magical feel. Only a little paint is needed; if you use too much, the cardboard may warp. Tilt and tip the colors a bit to let them flow if you wish.

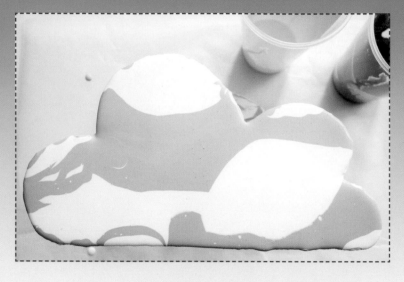

Lay the cloud flat and let it dry. Some warping might occur during the drying process; however, it will flatten out once completely dry after about 24 to 36 hours.

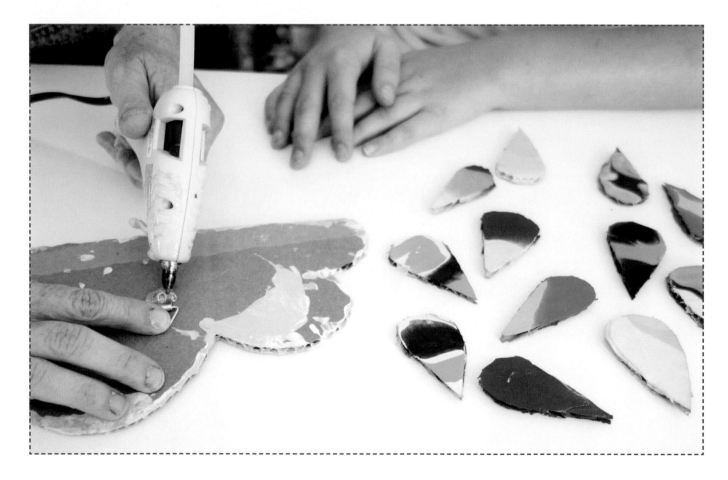

STEP 5

This step should be done by an adult. Hot glue the metal ring hanger to the back of the cloud.

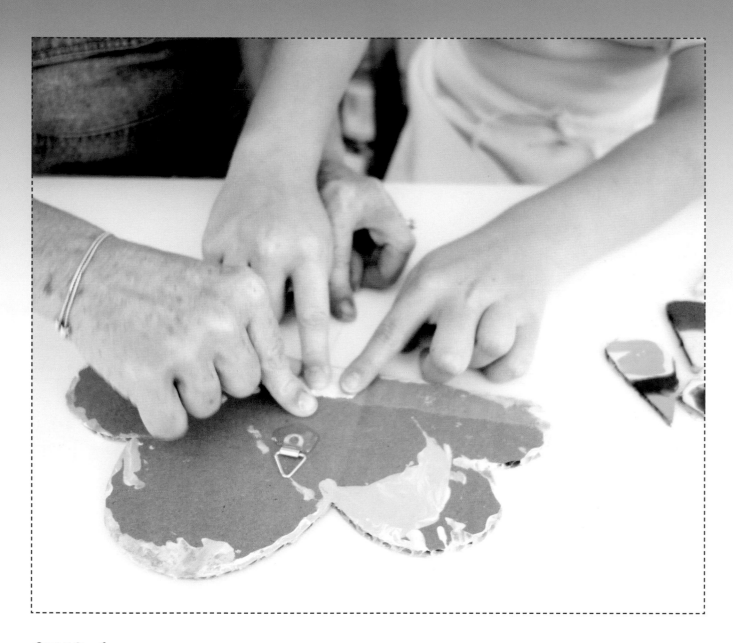

STEP 6

Cut 12-inch pieces of clear fishing wire to attach the raindrops to the back of the cloud. The strands of fishing wire should be spaced apart on the back of the cloud; add as many as you need. It may be necessary to trim off the ends of the fishing wire if they are too long to hide behind the last raindrop on each strand.

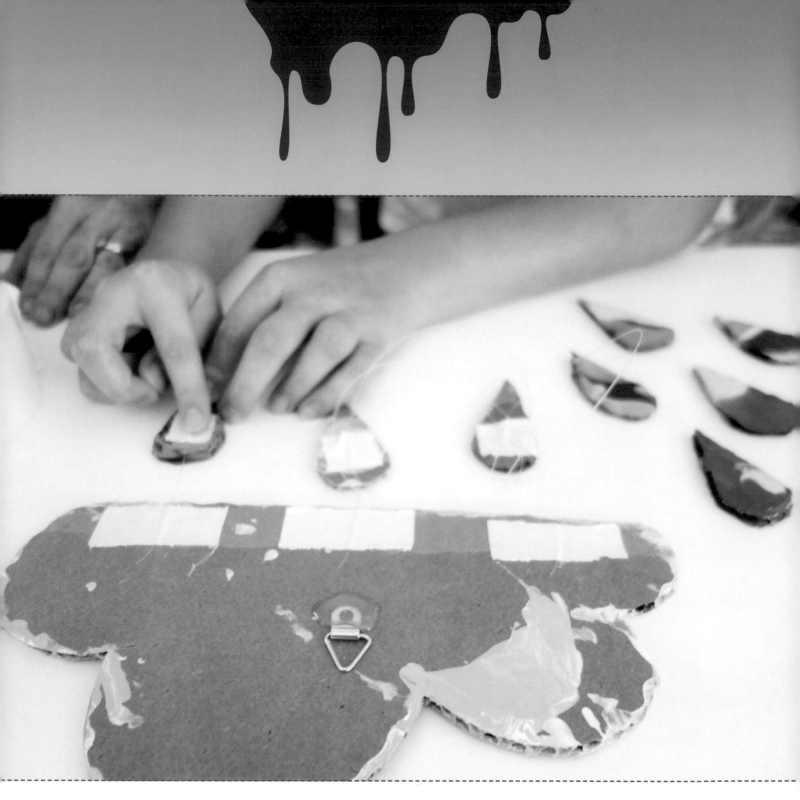

STEP 7

Attach all the raindrops to the fishing wire using duct tape. Space them as far apart as you wish.

Let kids take the lead when taping the raindrops—
even if they are falling in the wrong direction!

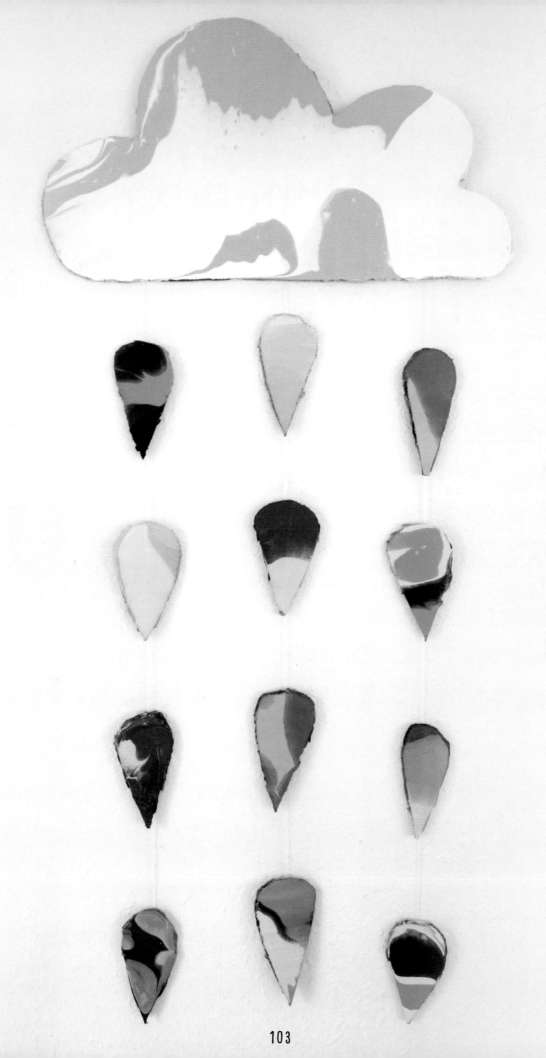

STEP-BY-STEP PROJECT

INITIAL IT

This is such a versatile project! Kids will love pouring paint on their initials to display them. We used Rust-Oleum® Specialty Magnetic Primer (see step 6), but this is not absolutely necessary. This project looks fantastic with or without photos, and your child can also use decorative washi tape for taping photos on the board as an alternative. The board can even be propped up on a shelf or hung on a wall! Either way, kids will love being able to pick and choose how to display their letters. Let's get started!

TOOLS & MATERIALS

- Vinyl tablecloth
- Acrylic paint
- Cups
- Pouring medium
- Water, rubbing alcohol, or dimethicone
- Wooden stir sticks
- Wood piece (12" x 12")
- Wood letter
- Wax paper
- Foil tray
- Optional: magnetic paint (such as Rust-Oleum Specialty Magnetic Primer)
- Paintbrush
- Scissors
- Double-sided foam tape
- Optional: hammer and sawtooth hanger
- Optional: strong miniature magnets or washi tape
- Personal photos

STEP 1

Set up your creative space by gathering the supplies and laying a vinyl tablecloth over your work surface.

STEP 2

Have your child pick out paint colors and pour them into individual cups. Then your child can add pouring medium to each cup of paint, following a ratio of about 2½ parts pouring medium to 1 part paint. Add a small splash of water and mix thoroughly, ensuring that there are no clumps. Use rubbing alcohol or dimethicone instead of water if your child wishes to add more cells to the final artwork.

STEP 3

With individual cups of paint thoroughly mixed, have your child create one dirty pour cup by layering the colors, little by little.

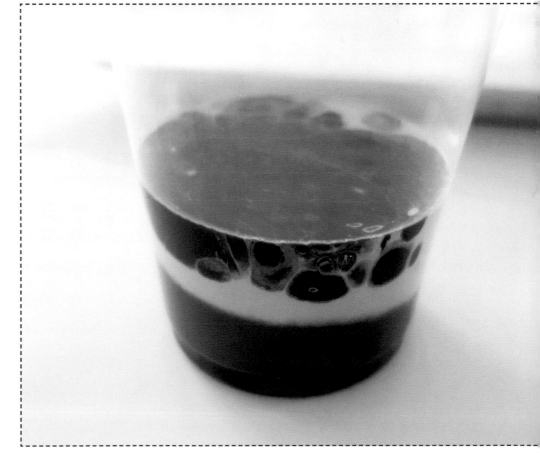

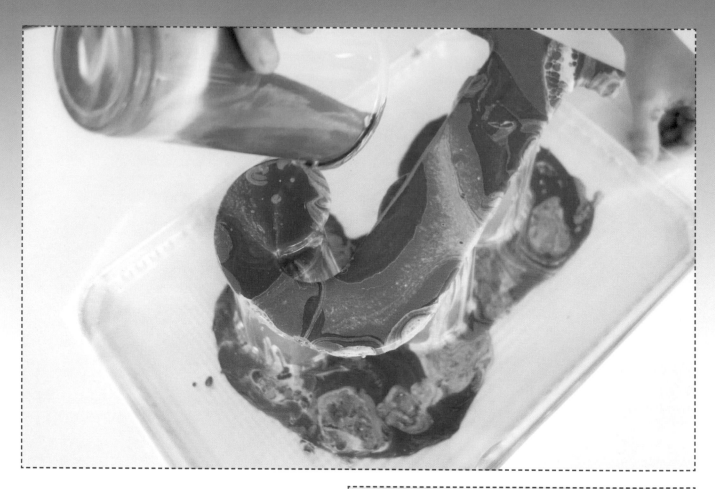

STEP 4

Lay a sheet of wax paper on the foil tray and place the wood letter on a few upside-down cups, making sure that the letter is balanced. Then help your child pour the dirty-pour cup over the letter. Paint should drip off all the letter's edges to ensure proper coverage. We did not have to do any tipping or tilting after pouring the paint; we let the shape of the letter control the flow of the paint.

STEP 5

Wait approximately 20 to 30 minutes after pouring the paint on the letter; then carefully move the letter, touching the edges only, onto a new sheet of wax paper so that the letter lies completely flat. Allow the letter to dry for 24 to 36 hours.

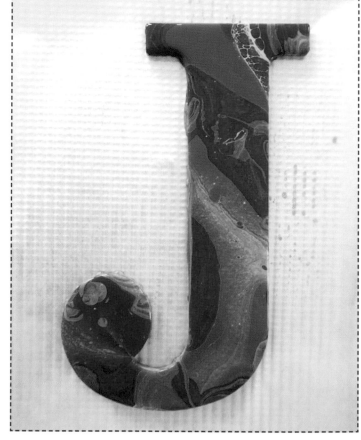

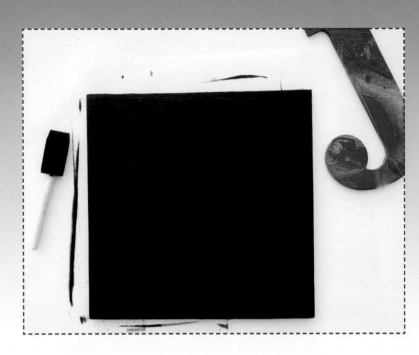

STEP 6

Paint the wood piece, which will be used as the background for the letter. We used a foam brush and applied three coats of Rust-Oleum Specialty Magnetic Primer. Very strong magnets work well with this paint. If using regular latex or acrylic paint for the background, a regular paintbrush works great! Let the wood dry completely.

STEP 7

Once the letter and background are completely dry, cut small pieces of double-sided foam tape and place them in various areas on the back of the letter.

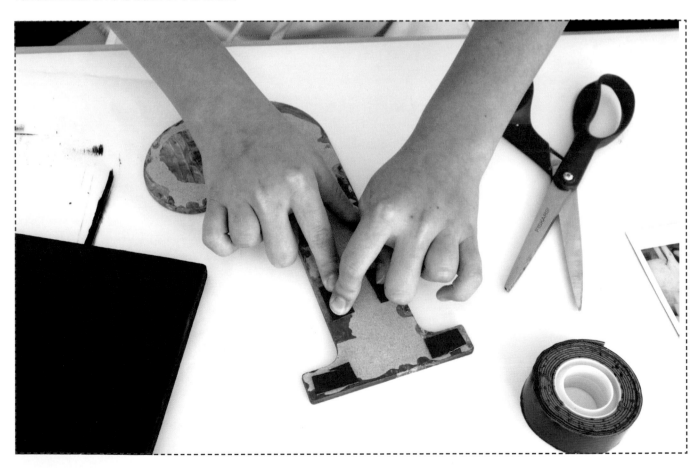

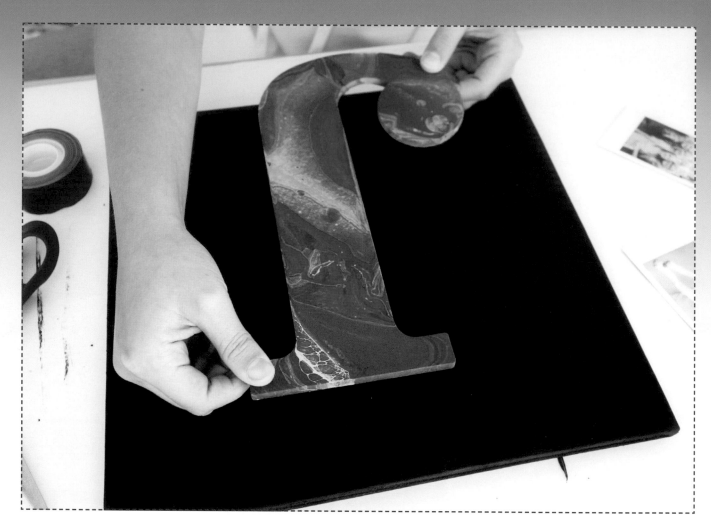

STEP 8

Press the letter into place on the board.

STEP 9

If your child would like to hang the board, hammer a sawtooth hanger onto the back.

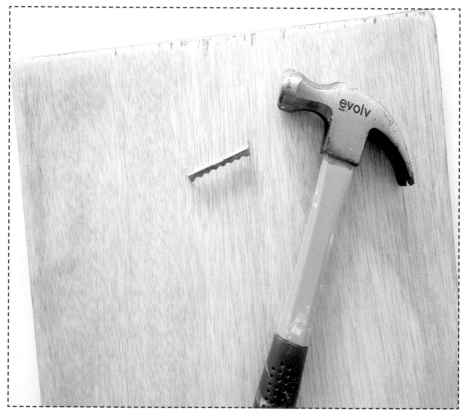

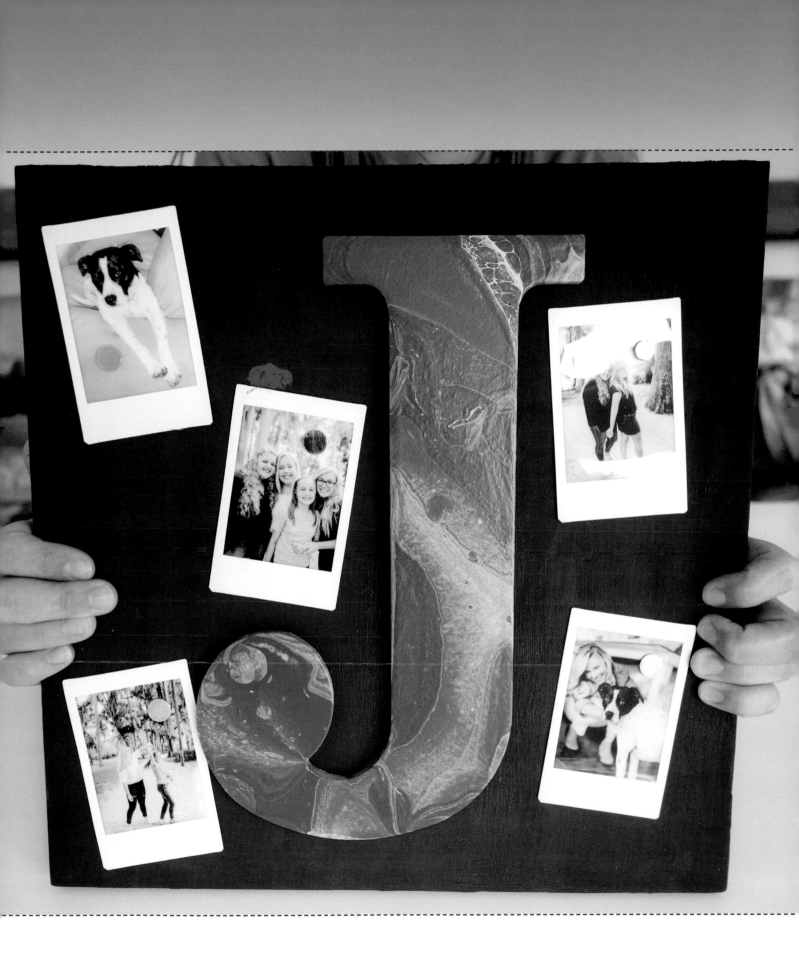

STEP-BY-STEP PROJECT

URBAN JUNGLE

Acrylic skins can be used to create a wide variety of objects and are great to have on hand for use on rainy days or when your child is in the mood to create something but doesn't have 36 to 48 hours to wait for fluid art to dry.

For this project, we decided to create an urban jungle-themed project and created a fiddle-leaf fig tree using an acrylic skin for the leaves and scrapbook paper for the pot. Other objects you could cut from an acrylic skin include a flower, a butterfly, a jellyfish, a turtle, a cactus, or even an ice-cream cone. The possibilities are endless! Creating a few additional acrylic skins while you have all your paint-pouring supplies out will inspire your child's creative energy for future projects!

Tools & Materials

- Acrylic skin (see pages 58-65 to create an acrylic skin)
- Canvas or wood surface
- Scissors
- Scrapbook paper
- Pencil and eraser
- Acrylic paint
- Paintbrushes
- Mod Podge glue

STEP 1

Prep your workspace and an acrylic skin. We created our acrylic skin using the flip cup technique and used a canvas for this project.

STEP 2

Cut out a pot shape from scrapbook paper. Place it on top of your surface to get an idea of where the tree trunk will go; then draw the tree trunk in pencil.

STEP 3

Paint the tree trunk and let it dry completely.

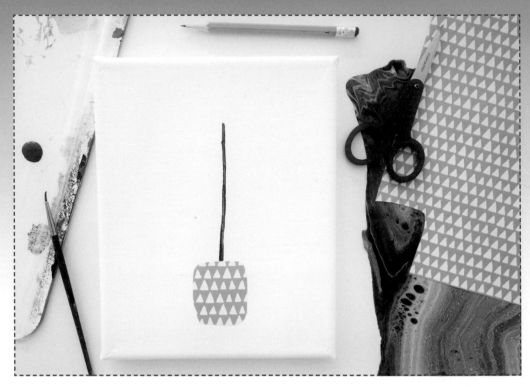

STEP 4

Using the acrylic skin, your child can cut out leaves of various shapes and sizes. Lay the leaves on various areas of the tree trunk to begin forming the shape of the tree.

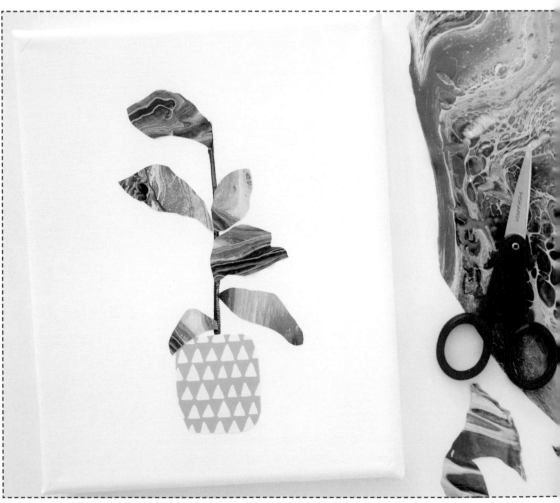

STEP 5

Glue the pot and leaves on the canvas. This step will work better if you keep all of the pieces in place and gently lift them to add glue underneath, firmly pressing each piece onto the surface. Once all of the pieces are glued down, brush a thin layer of glue over the entire surface. Have your child use their fingers to smooth out any air bubbles. Let the glue dry completely before moving on to the next step.

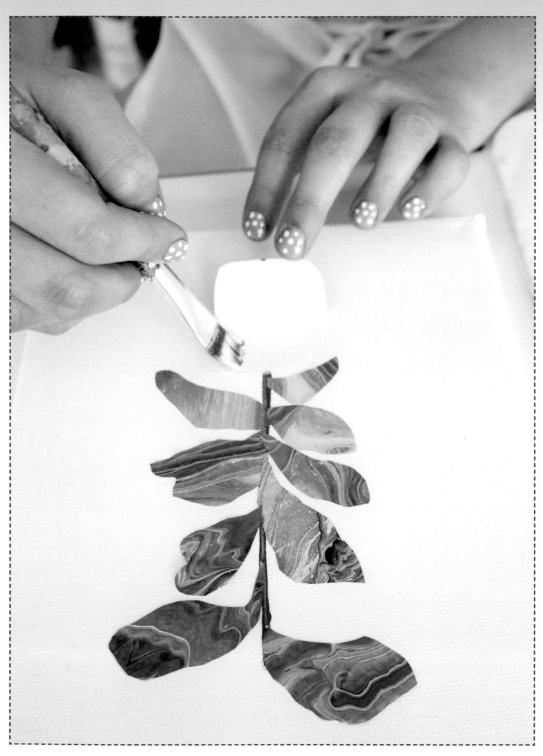

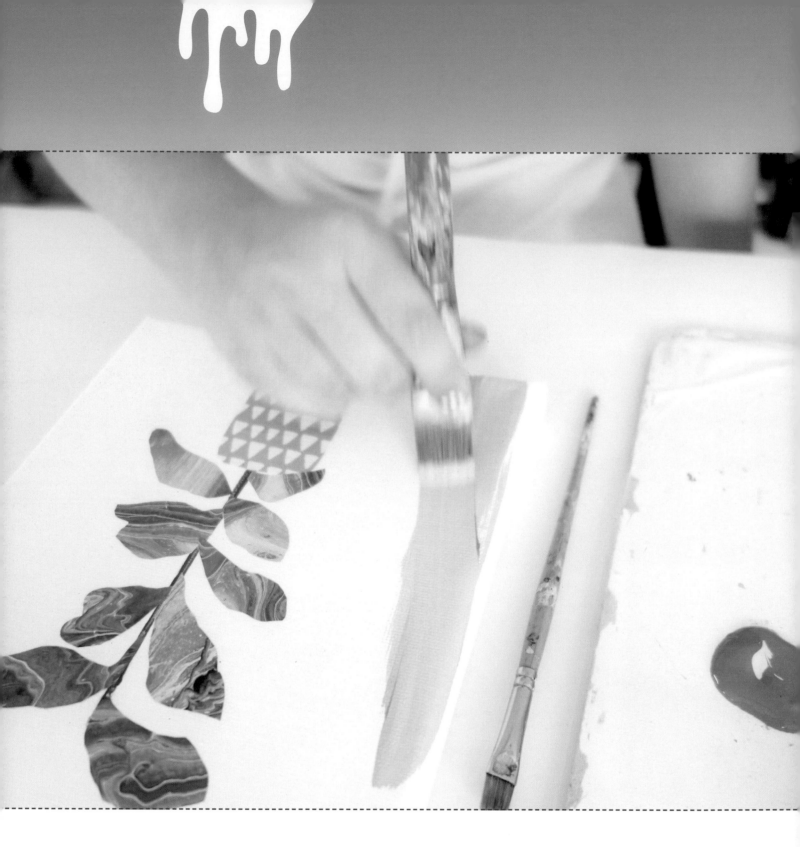

STEP 6

Using a vibrant, contrasting color, have your child paint the background. We chose to leave bits and pieces of our canvas white and showed rough edges, fun brushstrokes, and colors that mixed and mingled on the canvas. Let the paint dry completely.

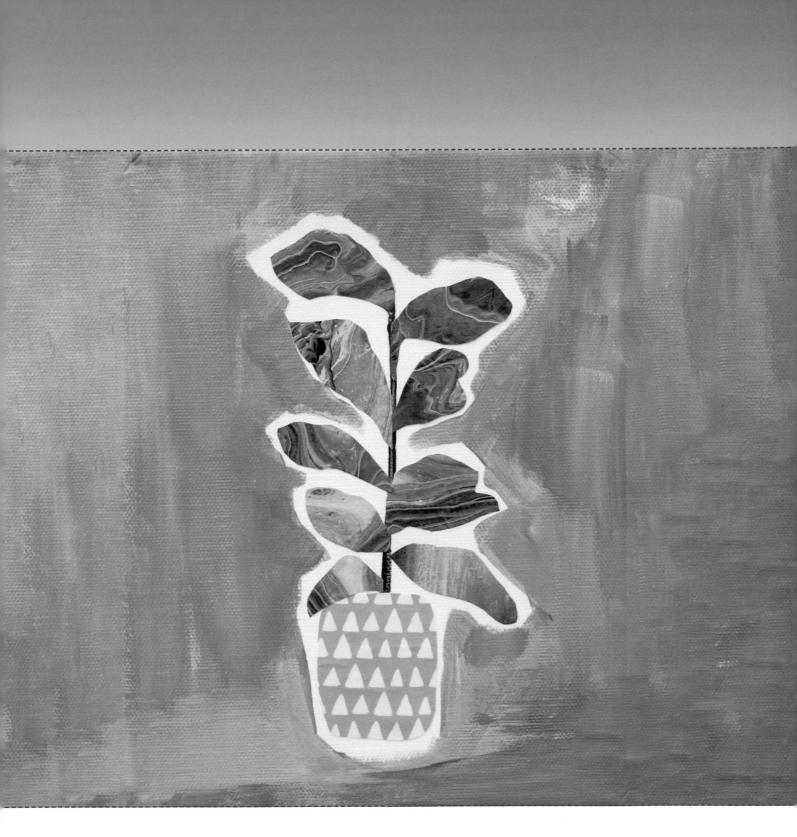

ACRYLIC SKIN COLLAGE

This is by far one of my favorite prompts in this book! Creative shapes, unintentional patterns, colors, and arrangement all play a role in getting the imagination flowing. Collage art is already fun to create, and featuring poured paint skins in the mix adds a whole new dimension of possibilities. Using leftover poured paint skins takes the stress out of choosing colors to pour. Instead, kids can see the colors and patterns they have on hand from previous projects and cut and shape the skins however they wish. Once they have their shapes, arranging them on paper and playing with the different layouts will only increase their creativity. Let's get started!

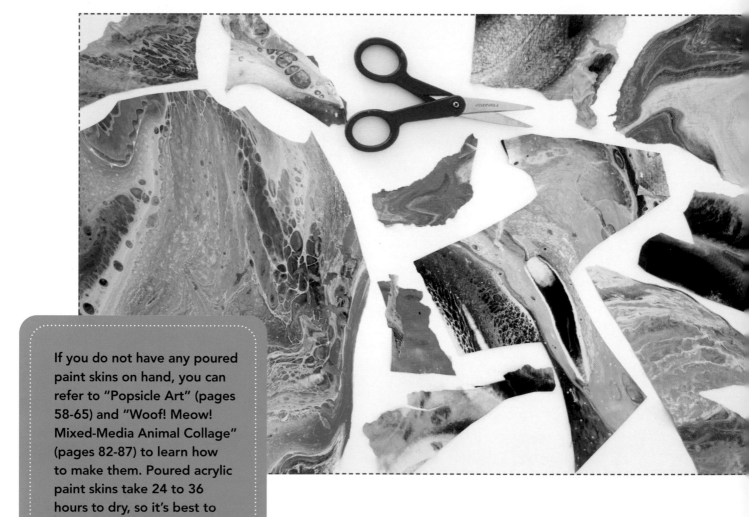

If you do not have any poured paint skins on hand, you can refer to "Popsicle Art" (pages 58-65) and "Woof! Meow! Mixed-Media Animal Collage" (pages 82-87) to learn how to make them. Poured acrylic paint skins take 24 to 36 hours to dry, so it's best to keep leftover pieces of acrylic paint skins on-hand.

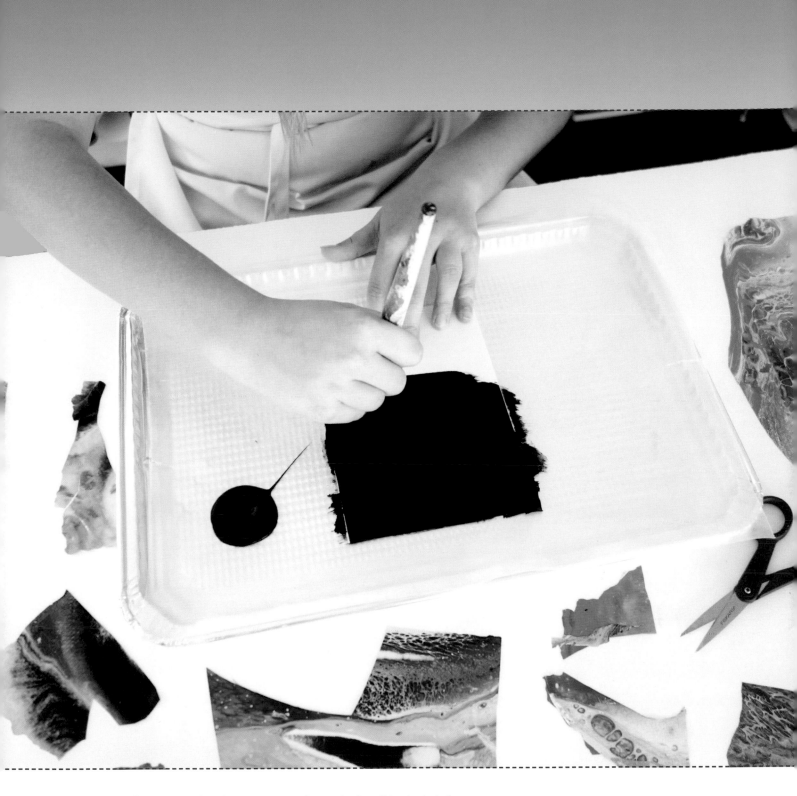

Prep your workspace and gather your supplies, which will include leftover paint skins, scissors, a paintbrush, Mod Podge glue, a sheet of Yupo Heavy paper, and one paint color to use as the background in your piece. Have your child paint the entire background of the paper; then let the paint dry completely.

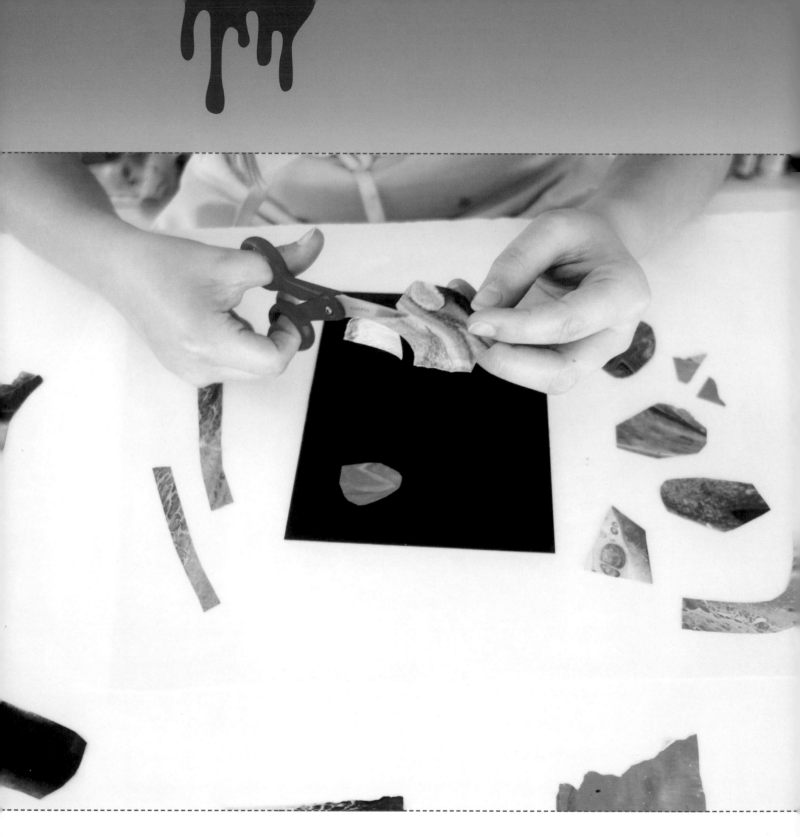

Have your child cut out random shapes from various paint skins.

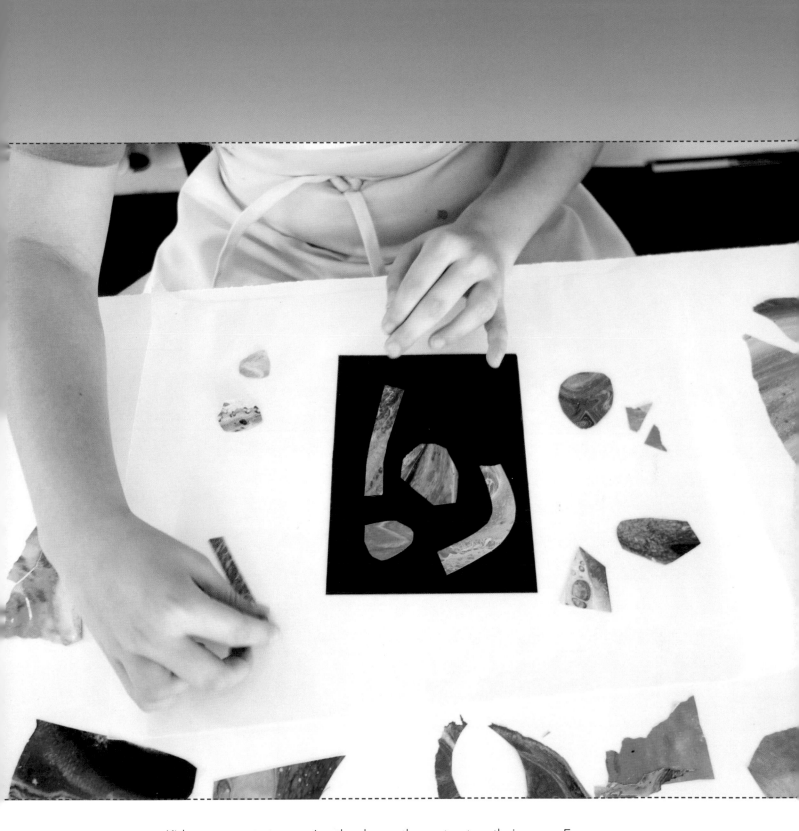

Kids can now start arranging the shapes they cut out on their paper. Encourage them to play with different arrangements before gluing the pieces in place.

Once your child is happy with the placement of the shapes, it's time to glue them in place. Have your child gently lift each piece one at a time, brushing glue onto the paper and then carefully pressing each piece in place. Once all of the shapes are glued down, brush a thin layer of Mod Podge over the paper. Kids can use their fingers to press and smooth any pieces that show air bubbles. Although Mod Podge goes on white, it will dry completely clear.

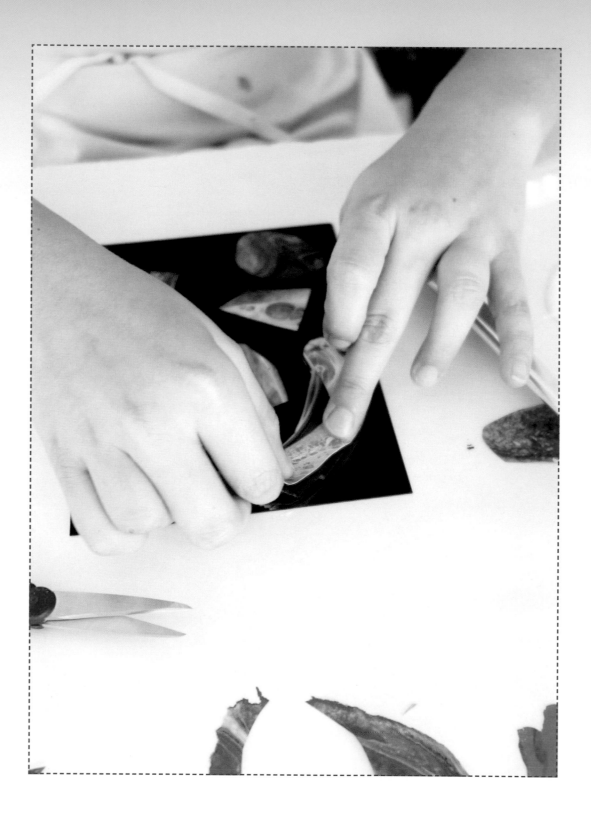

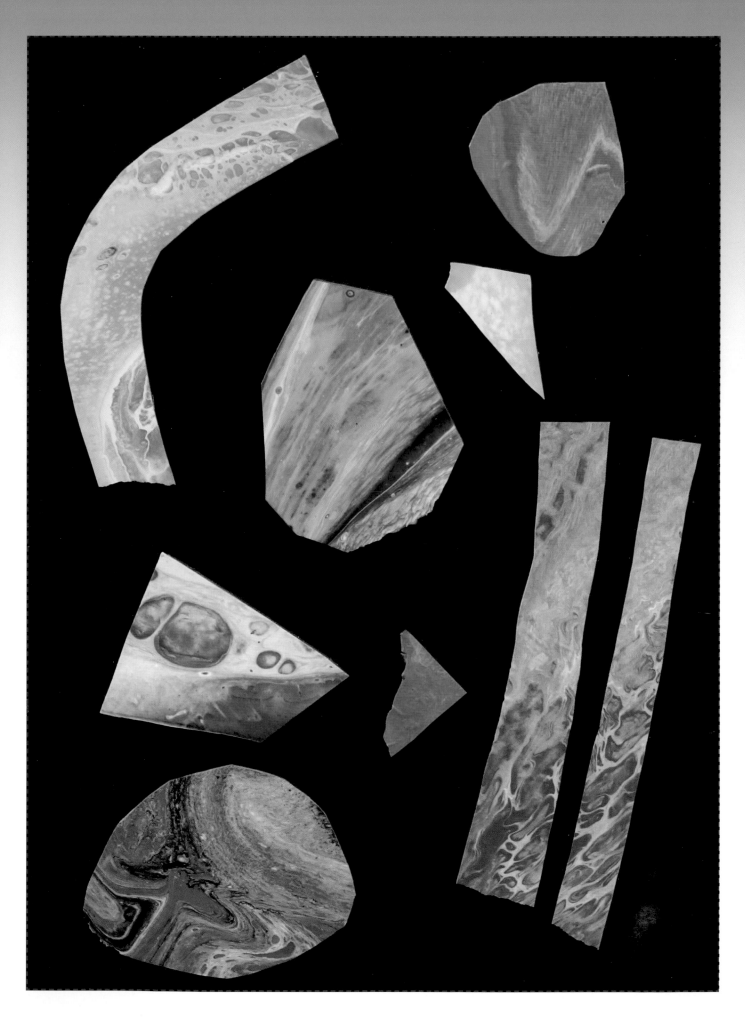

MINIATURE CREATIONS

These miniature creations make the perfect gift for just about anyone, and using leftover prepared paints can spark kids to truly use their imaginations. Limiting them to the colors they already have on-hand inspires them to think outside the box, and because these projects are small and inexpensive to create, children can experiment with all kinds of pouring techniques. Here are a few tips to inspire you and your kids on your miniature creative adventures!

Saving leftover paint from larger fluid-art projects can create instant fun when kids need something to do. Save your paint mixtures in the same cups they were created in, and then cover leftover paint cups with standard plastic wrap or aluminum foil, with a rubber band wrapped around the rim of the cup for extra protection. When you're ready to use the paint mixtures again, give them a little stir. A few of your cups may need a splash of rubbing alcohol or water if the paint becomes slightly too thick to pour.

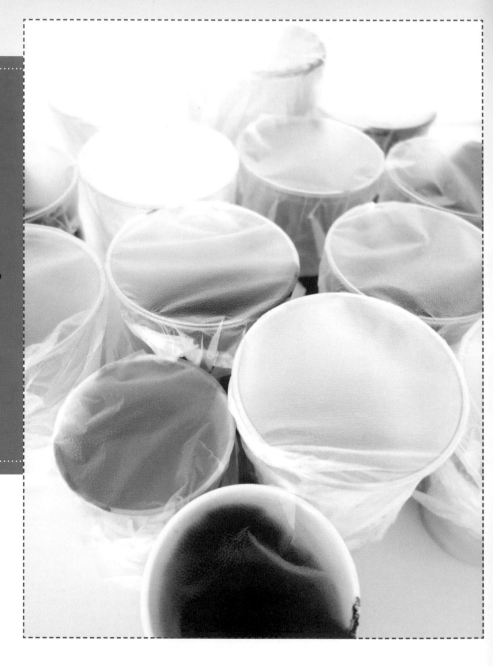

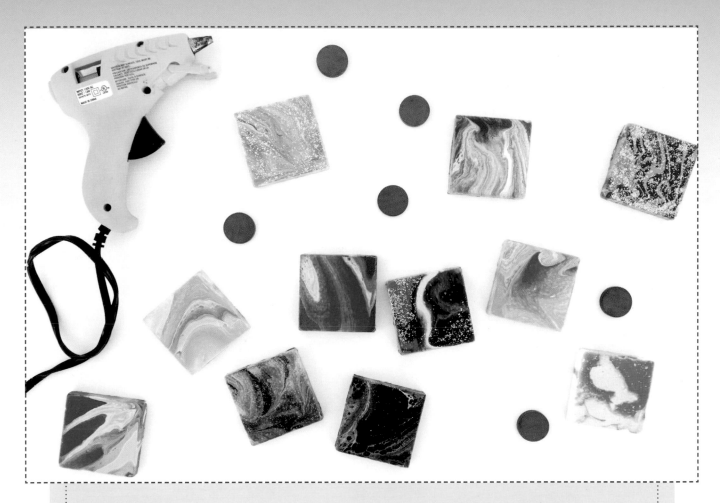

MIX IT UP

- Make dirty pour cups using two or three of the leftover paint colors in each cup, and take turns pouring each dirty pour cup, one section at a time, until the surface is completely covered. For example, pour one dirty pour cup over the left, middle, and right sections of a card, and fill in the two middle sections with a different dirty pour cup or even a solid color.

- Try adding extra-fine glitter to one of your paint mixtures, or sprinkle it over a few areas of your artwork.

- Immediately after making a dirty pour on a surface, add solid stripes, pouring from one side of the surface to the other. No need to tip or tilt; let the solid-color stripes stay solid and just go with the flow!

POSTCARDS

YUPO Heavy paper is fantastic for pouring! Paint sits well on it, and the paper will not buckle under the weight. The 5" x 7" size is perfect for fluid-art postcards—no trimming required!

First, line a foil tray with wax paper, and lay each postcard on top of four upside-down cups. Pour your paint mixture onto the postcards and then, when the postcards are almost covered, do not lift them from the cups. Instead, gently tip and tilt the foil tray to move the paint so that the paint doesn't drip onto the back of the postcards. Leave the postcards on the cups to dry.

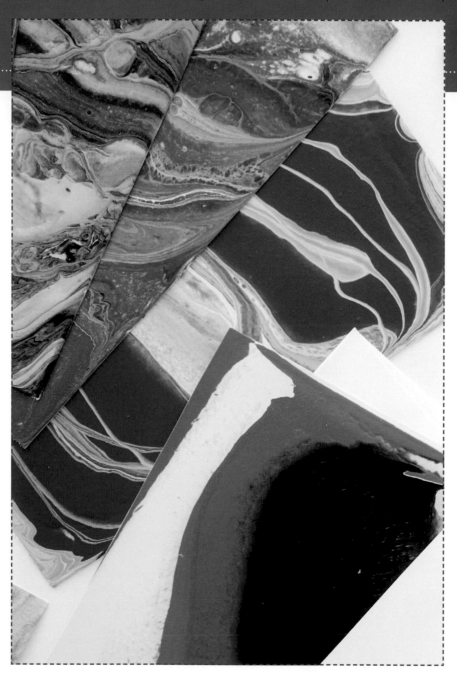

BOOKMARKS

9" x 12" YUPO Heavy paper is a great surface for fluid-art bookmarks. Trim the paper to the size of your choice before pouring on it; I trimmed mine to 8" x 2½".

Line a foil tray with wax paper and lay each bookmark on two upside-down cups for support. As with the postcards, after pouring paint onto your bookmarks, tip and tilt the foil tray to finish covering the bookmarks. Leave the bookmarks on the cups to dry and trim the edges as needed using scissors once the paint is completely dry.

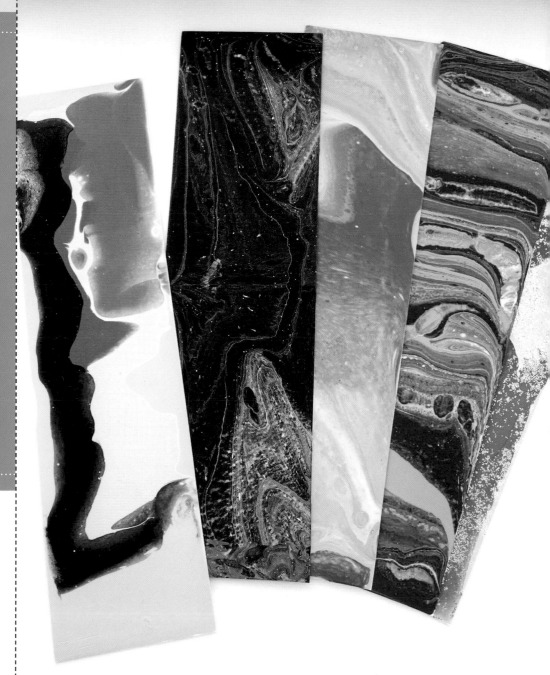

MAGNETS & MINIATURE CANVAS PANELS

Using a foil tray lined with wax paper, place each 2″ x 2″ marble tile or miniature canvas board directly on the wax paper or on top of an upside-down cup. After pouring on the tiles or canvas boards and letting the paint dry completely, use scissors or a craft knife to trim or scrape off any paint that dried on the bottom edges. Then use a hot glue gun to adhere a magnet to the back of each tile. Only adults should complete these last two steps!

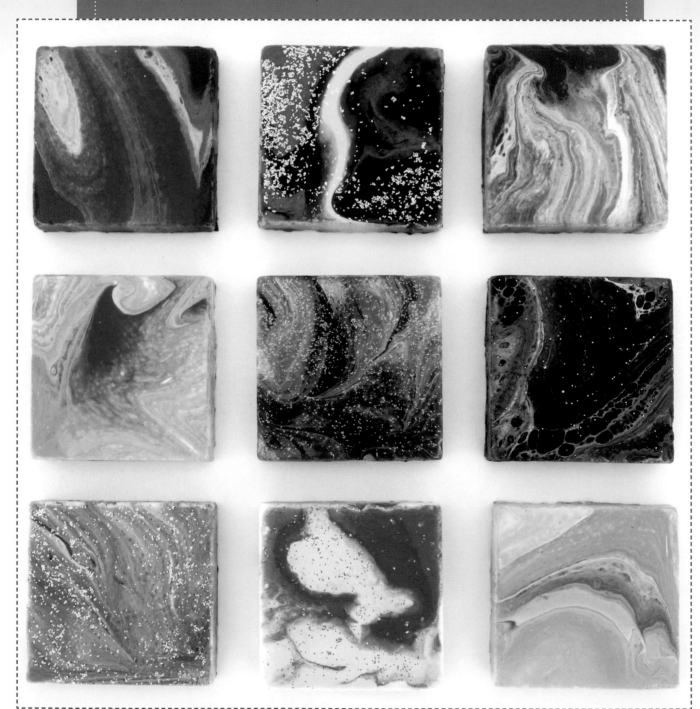

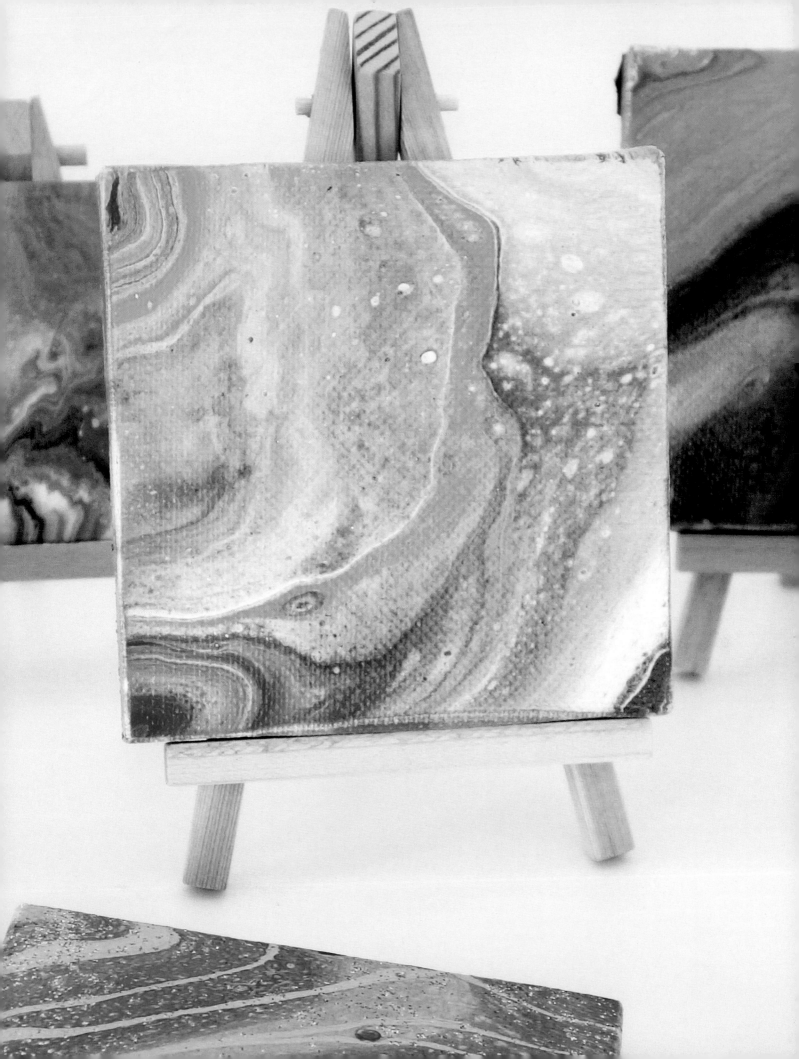

ABOUT THE ARTIST

Photo by Mya Blanton

Jennifer McCully began her creative journey as a graphic designer and stumbled upon mixed media art along the way! Her childlike creations and colorful spirit are strewn across vibrant canvases that leave one feeling energetic and inspired. Her art evokes happiness, and her inspiration is drawn from everything around her. Jennifer's unmistakably fun and fresh art is available through Oopsy Daisy, Fine Art for Kids and Hobby Lobby, as well as Etsy and several Florida-based galleries. Jennifer also offers an annual mixed media art camp for kids ages 7+. She lives in Florida with her husband and their four girls. Visit www.jennifermccully.com.

ALSO IN THIS SERIES

**The Grown-Up's Guide
to Making Art with Kids**
978-1-63322-739-2

**The Grown-Up's Guide
to Crafting with Kids**
978-1-63322-860-3

Inspiring | Educating | Creating | Entertaining

Visit www.QuartoKnows.com